IMAGES
of America

COMMERCE CITY

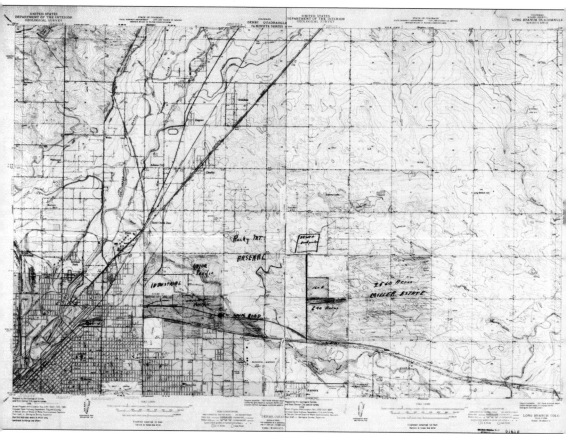

Two maps are combined here. The left side is Derby, Colorado, and the right side depicts Longbranch, Colorado, in 1938. (Colorado Historical Society.)

ON THE COVER: In 1942, America was gearing up for World War II. That year, the army purchased nearly 20,000 acres northeast of Denver to build a chemical weapons plant to support the war. This land became the Rocky Mountain Arsenal. The facilities were built in the center of the arsenal with a buffer zone of open land around the perimeter. Many women worked here, since many men were overseas fighting in World War II. (U.S. Army.)

IMAGES
of America

COMMERCE CITY

Debra Bullock

ARCADIA
PUBLISHING

Published by Arcadia Publishing
Charleston, South Carolina

Printed in the United States of America

Library of Congress Control Number: 2009935201

For all general information contact Arcadia Publishing at:
Telephone 843-853-2070
Fax 843-853-0044
E-mail sales@arcadiapublishing.com
For customer service and orders:
Toll-Free 1-888-313-2665

Visit us on the Internet at www.arcadiapublishing.com

*This book is dedicated to the people of Commerce City,
past, present, and future, and in memory of my mother,
Betty Lavonne Hage. She would have loved this book.*

CONTENTS

ACKNOWLEDGMENTS

My deepest appreciation goes to my patient and supportive family: my husband, Rene, for his encouragement and patience, and my daughter, Dami, for her belief and support in this project.

I would like to thank all the residents of Commerce City who told their stories and shared their pictures and articles. Without all of you, this book would not have been possible.

Many of the following people gave their time and treasures to me to accomplish this book: E. E. Casey Hayes, Denver Black, Lucille (Egli) McIntyre, Ernie Maurer, Harlow and Shirley Leeper, Bobbie Crall, Lester and Mary Arnold, Warren and Carolyn Kerls, Dorothy Miller, Ann (Johnson) Emerson, Bob and Beverly Aragon, Laura Bauer, Chuck Saunier, Bob Gehler, Larry and Darlene Ford, Winnie Jergensen, Al and Jean Klein, Rick and Patti Teter, Reba Drotar, and JoAnn Stevenson.

I especially want to thank Susan Drobniak from the Rocky Mountain Arsenal for being so cooperative and excited about the book, and Jim Jones, Pam Droesch, Blair Corning, and Bob Aragon from the South Adams County Water and Sanitation District for the wonderful tour and information they provided. I thank Bob and Dorothy Hutchings for their help, dedication, and knowledge of the fire department, and Lt. Chuck Sauniers and Comdr. Larry Woog for helping me with information on the Commerce City Police Department.

I also wish to thank my editor at Arcadia Publishing, Jerry Roberts, for his expert guidance.

INTRODUCTION

In the mid-1800s, many trading forts were built along the Platte River. In 1832, Louis Vasquez built a trading post on the east banks of Cannonball Creek. Today this stream is known as Clear Creek. Vasquez's Fort Convenience was located in the area of present-day Adams County Social Services Building at 4200 East Seventy-second Avenue.

The first settlers came into the area that now comprises Commerce City around 1850. Some of them arrived in covered wagons. Nine Mile House, located in the Dupont area, was one of the stage stations on the Overland Route. It was situated approximately where Eighty-eighth Avenue and Interstate 76 are today. The Homestead Act of 1862 allowed settlers 160 acres of free land for farms and ranches. In 1867, Danish settlers along Sand Creek began hog farming. Water was supplied from local wells and from ditches that ran from the South Platte River.

Adams County School District 14 began operating in 1871 as a one-room schoolhouse. Riverside Cemetery was founded in 1876, and the Colorado State Legislature created the office of "Fish Commissioner." In November 1881, construction began on a new state fish hatchery near Dupont. The hatchery was rebuilt in 1889 and again in 1922 and closed in 1963. In 1973, the Division of Wildlife remodeled the old hatchery structure to become a Hunter Safety Rifle Range. The buildings are located on Eighty-eighth Avenue west of Interstate 76.

Derby has been a community for more than a century but has never been officially recognized as a town or city by the State of Colorado. As early as 1887, records state, Derby was a Burlington Northern Railroad station. The towns of Derby and Irondale were laid out in 1889. Irondale was first settled in 1889, named after a foundry that was opened that year. It was incorporated as the Town of Irondale in 1924. In 1926, Charles Black was elected mayor. Six trustees were Nettie Bruce, E. Sebastiana, Pete Palombo, Carl Faller, A. D'Andrea, and M. Salmonese. The town was unincorporated in the 1930s due to increasing vacancy but remained a community.

Rose Hill Cemetery was established in 1892 by the United Hebrew Cemetery Association. The current Denver Botanical Gardens was a cemetery in 1892, and the Jewish graves were moved to Rose Hill Cemetery and other cemeteries throughout the city. The area was an open plain.

Old Arapahoe County extended all the way to the Kansas border and included the present-day city of Commerce City until Adams County was created in 1902. New schools were added to the area in 1899 and later in 1907. Adams City was laid out in 1902 with developers hoping the county seat would be established there. However, Brighton was elected county seat on November 8, 1904, with 1,103 votes to Adams City's 719 votes. Adams City never became a town and was vacated by 1922.

Many granges were established throughout the area, such as Henderson Grange (1890), Riverdale Grange (1910), and Rose Hill Grange (1917). In 1912, land was donated by John Reither to build Longbranch School. There were three schools in the area that would become the Rocky Mountain Arsenal: Longbranch, Avoca Valley, and Rose Hill Schools.

In the mid-1920s, the first telephone company in the Adams County area was located in a home close to the old Hazeltine School. A fire burned the home, and the telephone company was moved to the corner of Seventy-second Avenue and Highway 85. In 1947, the phone exchange moved to Seventy-second Avenue, where the current AT&T Building is located. The phone number prefix started with Atlas-8.

Until the late 1920s, the area was mainly a farming community where livestock, truck gardens, and wheat fields flourished. Between 1923 and 1954, many dairies were located in the area, such as IXL Dairy, Model Dairy, Johnson Dairy, Harmony Dairy, Garden Farm, Starlight Dairy, Morning Sun, and Oak Leaf Dairy.

Industry moved into the area, and refineries were established in the 1930s. At least 14 fish hatcheries located along the Platte River raised trout. Families that established the trout farms were the Hutchings, Fadens, Petersons, Kinneys, Manns, Miners, Otto Hutchinsons, and many more. Grain elevators were built in 1937 by Oscar Mallo. The Hungarian Flour Company began operations in 1938.

Some of the first roads to be built in the area were Irondale Road, now known as Eighty-eighth Avenue, and Model Road, known today as Sixty-fourth Avenue. Both of these roads went through Commerce City and extended east to where Denver International Airport is located. These roads were closed off when the Rocky Mountain Arsenal came into existence. The Box Elder community was located on the land that now occupies Denver International Airport.

The Rocky Mountain Arsenal was founded in 1942, east of the growing community, in support of World War II. The South Adams County Volunteer Fire Department was founded in 1942, and Adams City was beginning to redevelop with new houses being built. The Adams Heights subdivision was established in 1946. In 1946–1947, Adams County School District 14 was formed from surrounding schools, with the first official class from Adams City High School graduating in 1949.

The football field was dedicated to Ed Krogh in October 1948. The field house was dedicated to Al Krogh, Ed's son, in 1961. New roads were being built in the area, and some of the major ones were Highways 6 and 85 in 1948 and Highway 2 in the early 1950s. In 1950, the Commerce City Police Department named its first police chief, Edward A. Marzano.

The South Adams County Water and Sanitation District was formed in 1951 at the same time Denver was considering annexing the area. A plan to incorporate all of southern Adams County was developed. On July 8, 1952, a group of about 300 residents voted for incorporation of Commerce Town, comprising neighborhoods such as Rose Hill and southern Adams County. Alfred Krogh was elected mayor along with six trustees: Sam Amato, Castor Hansen, John Juhl, John Kemp, Carl Lundgren, and Paskey Teto.

In South Adams County, 15 of the 19 hog ranches were in the new Commerce Town area. Industries in the 1950s included six oil refineries, two grain elevators, and a dozen other major manufacturing and freight-hauling businesses. Several other businesses were established in the Derby area such as Latorins, Lucas Furniture, Ben Franklin, Hi-Lo, Wolf's, Derby Beauty Shop, Derby Lanes, Hieny's Shoe Service, and Wohlers Shoe Store. In 1958, the Rainbow Bread Company was established. In 1965, the banks of Sand Creek and the South Platte River overflowed and caused extensive damage, resulting in Highway 270 being built.

Commerce Town annexed part of Derby in 1962, increasing the population fourfold. This was enough for the town to gain status as a city. The name was duly changed to Commerce City. A new city hall was completed in 1967. It housed the first city library; the result of efforts by Mayor Leroy Fields and Charlene Jaramillo. Commerce City staffed the library, and the Adams County Public Library supplied books and shelving. Lou Jaramillo and Marge Christenson (the first woman on the Commerce City Council) directed landscaping efforts. In 1967, the first park to be built in Commerce City was Gifford Park, located at 6120 Monaco Street.

In the 1970s, many parks were established within the city: City Park (1971), at 6015 Forest Drive; Veterans' Memorial Park (1971), at 6150 Parkway Drive; Fairfax Park (1973), at 6850 Fairfax Drive; Monaco Park (1973), at 5790 Monaco Street; Olive Park (1974), at 6325 Olive Street; and

Freedom Park (1974), at 6270 Oneida Street. A new library branch opened in Commerce City in 1977 at 7185 Monaco Street.

More parks were built in the 1980s, which included Adams Heights Park, at 6625 Brighton Road; Derby Park, at 7305 Monaco Street; Los Valientes Park, at 7300 Magnolia Street; and Monaco Vista, at 6250 Monaco Street.

Commerce City is the location of the last drive-in theater in the Denver area, the Eighty-eighth Avenue Drive-In, built in the mid-1970s and located at 8780 Rosemary Street. The first fast-food chain to build in Commerce City was McDonald's, which opened a restaurant in 1979. In the 1980s, the city and the water department were in negotiations over the contamination issues at the Rocky Mountain Arsenal. These negotiations lasted for many years and involved many agencies.

In 1987, the Adams County voters approved to allow Denver to annex lands from unincorporated Adams County to build Denver International Airport, which opened in 1995. The *Commerce City Beacon* was established in 1988. Norm and Janet Union were the owners of this local paper, which closed in March 2009. The Buffalo Run Golf Course was established in 1996.

In 1999, Larry Ford, the South Adams Water and Sanitation District manger, and Bob Gehler, the city attorney, negotiated agreements with water and sewer for the development in the north areas. On April 6, 1999, the residents voted on an initiative not to restrict growth in the northern areas, which allowed the city to double in population and provided great potential for residential, retail, and commercial development. As a result of this election, one of the first housing developments to be built was the Eagle Creek subdivision at Ninety-sixth Avenue and Highway 2 in 1999. River Run followed this at 112th Avenue and Peoria Street. In 2002, Belle Creek was established, and in 2003 Reunion and Fronterra were established along with many others.

Pioneer Park and River Run Park were two of the most recent and nicest parks built in 2004. Pioneer Park has three ball fields that were completed in phase one and batting cages, a skate park, bike hills, and another ball field when phase two finished in 2008. In 2005, the Prairie Gateway was formed.

On April 3, 2007, the citizens of Commerce City overwhelmingly voted to retain their city's name in the city election, and the new city hall complex, a world-class soccer stadium, and the new Quebec Parkway were opened. In 2009, a new state-of-the-art high school opened at 7200 Quebec Parkway.

At the close of the first decade of the 21st century, more than 40,000 residents live in Commerce City's 41 square miles.

This is the current Commerce City logo. (City of Commerce City.)

One

Commerce City and Surrounding Areas

Derby has remained a neighborhood business district within the boundaries of Commerce City. In the early years, Derby's location served as a crossroads for a railroad station located in the area of Seventy-second Avenue and Highway 2. Derby was a small town with two stores, a railroad stop, lumberyard, and church. It was named after George Horatio Derby, a young army officer who conducted surveys and explorations in 1889. Derby's first post office was established in 1910.

Early maps referred to Irondale as Ironton because of a stove factory that was opened in 1890 by Charles Kibler Jr. The Kibler Stove Works went out of business in 1893. The factory was located adjacent to where the old Irondale School was located at 8702 Rosemary Street.

The area of Rose Hill was originally located along Sixtieth Avenue, south to Sand Creek and east of what is in the 21st century the Rocky Mountain Arsenal Wildlife Refuge. The first Rose Hill School was located on the arsenal and then moved to 6900 East Fifty-eighth Avenue.

Dupont is an unincorporated Adams County town containing a U.S. post office established in 1926. Dupont was named after the Dupont de Nemours family, which owned a business and buildings. Some businesses in Dupont were the Wheel Bar, formerly the Nine Mile Inn, and an auto racetrack and airport.

The City of Adams was renamed Adams City in 1947, both named after Alva Adams, a governor of Colorado. There were several store buildings, a meeting hall, grade school, high school, and a few houses. A post office was established in the mid-1920s and moved to 6655 Brighton Road in 1969, when Lloyd Coulter was the postmaster. Some of the families farming vegetables on the original Adams City lands were the Riggis and the Saurinis. The Gahagens had an iron recycling business. The Adams City Baptist Church was the local house of worship.

Riverside Cemetery, founded in 1876 along the South Platte River, is located in the city's southwest corner at East Fifty-second Avenue and Brighton Boulevard. Many famous people in Colorado history are buried in Riverside Cemetery, including the first governor and his wife, John and Margaret Gray Evans. Riverside's 77 developed acres include 67,000 graves. Fairmount Cemetery Company has owned and operated the site since 1900. (Fairmount Heritage Foundation.)

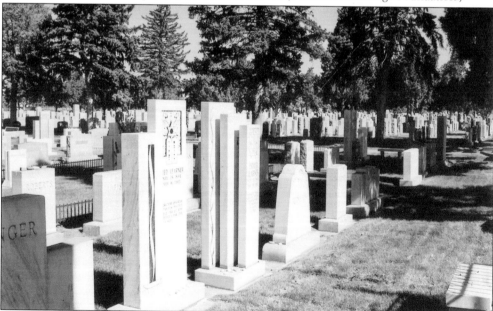

United Hebrew Cemetery was founded in 1892 in the heart of historic Commerce City. At the time it was established, the cemetery sat on the open plains. The 20-acre piece of land was a gift from the community. The first grave recorded was in the spring of 1892. The cemetery was later named Rose Hill Cemetery, named after General Rose, a Jewish general during World War II. The elevation of the Rose Hill subdivision is higher than the rest of the land. (Photograph by Debra Bullock.)

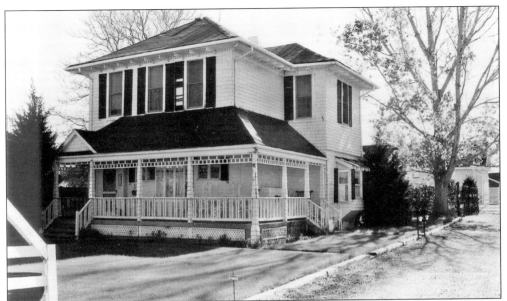

Pictured here is one of the oldest homes in Commerce City, located at 6140 Holly Street. This house, built in 1892, stands on property that was once a 160-acre dairy farm called Echo Vale. The first owners were the Maybees, who purchased the land from the Union Pacific Railroad in the late 1800s. Dottie Bakke is the current owner, and she purchased it with her husband, Duane, in 1965. (Dottie Bakke.)

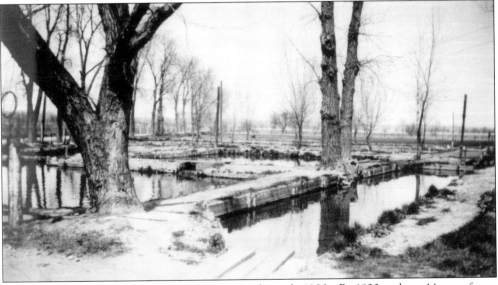

Raising trout commercially began in the area in the early 1900s. By 1930, at least 14 trout farms were located north of Riverside Cemetery for 6 miles along the east bank of the South Platte River. These farms provided fresh trout to all major hotels and restaurants in Denver and for railroad dining cars on the 50 or more passenger trains passing through each day. Live stocking of private waters became popular after World War II. Pictured here is the Fish Hatchery, located north of Interstate 76 at 9550 Monaco Street, where Maxine (Peterson) Ciri lived, and where her parents and grandparents lived. They were trout farmers who came from Sweden in 1880. (Dorothy Miller and *Commerce City Beacon*.)

This is one of the first churches in the Derby area, which was built in the early 1900s and is located at Seventy-second Avenue and Newport Street. (Photograph by Debra Bullock.)

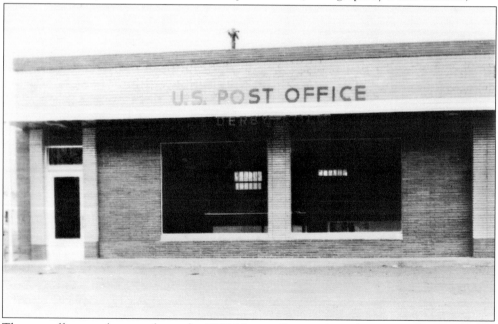

The post office seen here was located at 7280 Monaco Street, where the present-day Ace Jewelry Store now stands. The first Derby Post Office was established in 1910; Mrs. C. J. Irwin was the postmaster. (John Gilman, Hi-Lo Market.)

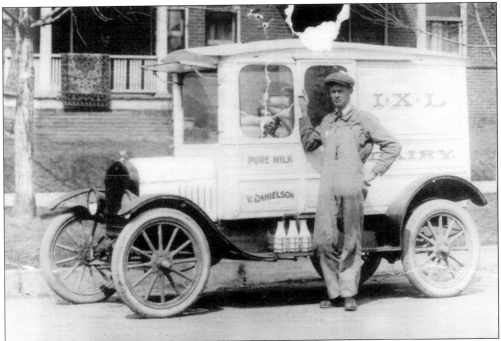

From about 1915 to 1954, there were several dairies in the Commerce City area operated by Swedish people. Some of the families that had dairies were the Johnsons, Eglises, Lundgrens, Lindballs, Jacobsens, and Schweiders. Some of the dairies in the area were IXL Dairy, Oak Leaf Dairy, the Morning Sun Farm, Model Dairy, and the Starlight Dairy. Pictured here is Axel Johnson, who owned the IXL Dairy. (Dorothy Miller.)

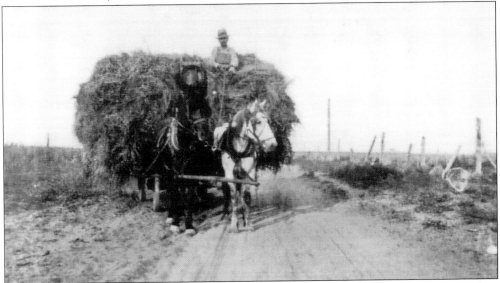

In addition to dairy and hog farms, there were cattle farms and truck farms harvesting produce such as cabbage, cauliflower, celery, and lettuce along the South Platte River. These truck farms were run primarily by people of Italian or Japanese ancestry. Some of the families that had hog and cattle farms were the Kroghs, Courtrights, Kerricks, and Durocs. (Dorothy Miller and *Commerce City Beacon.*)

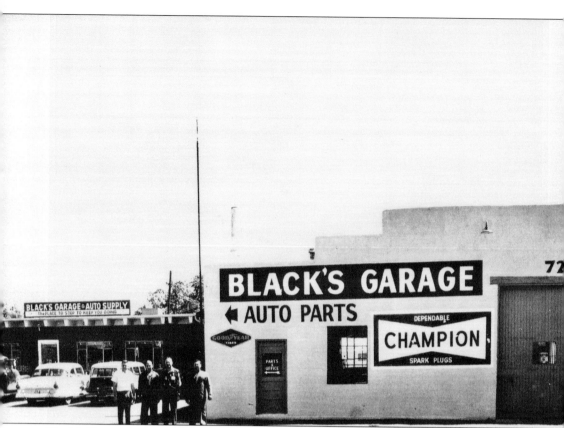

Black's Garage, located at 7200 Monaco Street, was established in 1918 by Ida and Denver Black Sr. They sold cars and auto supplies and provided maintenance. The Blacks have been responsible for employing dozens of local people over the years. (Denver Black.)

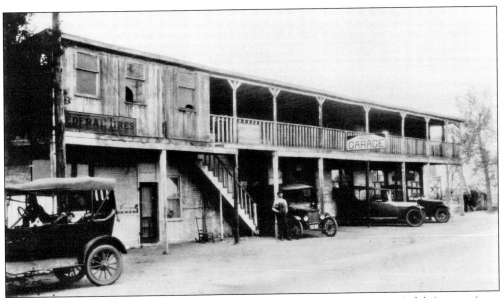

The Model Garage, depicted here in 1919, was located in Adams City on Model Avenue (now Sixty-fourth Avenue and Brighton Boulevard). A boating lake and band gazebo surrounded with trees existed behind it, and a dance hall and beer garden with tables was located under the trees as lilacs grew nearby. The dance hall had a maple floor and tables topped with Coca-Cola ads. In 1925, the top floor was removed, and the bottom floor was remodeled to provide tourist rooms and a garage. (Dorothy Miller and *Commerce City Beacon*.)

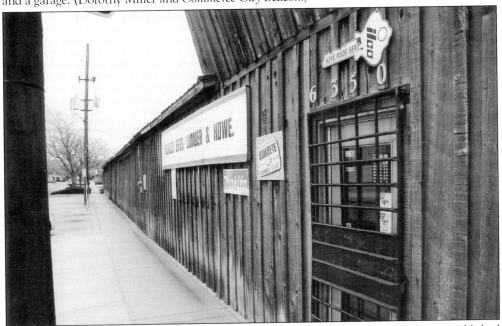

This is Younger Brothers Lumber, located at 6350 East Seventy-second Place, which was established in 1925 as Derby Lumber by the Westerman Family. The Younger brothers purchased it in 1972 and named it Younger Brothers Lumber and Construction. The five Younger brothers were Walt, Henry, Leo, Clarence, and Derell. Derell and his son Trent are the 21st-century owners. (Dorothy Miller and *Commerce City Beacon*.)

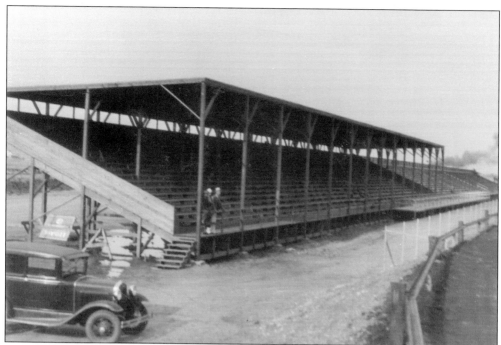

In Dupont during the 1930s was an auto racetrack, located at Seventy-sixth Avenue and Dahlia Street. Some of the cars could travel 150 miles per hour. They also had motorcycle races every Sunday. (Dorothy Miller and *Commerce City Beacon*.)

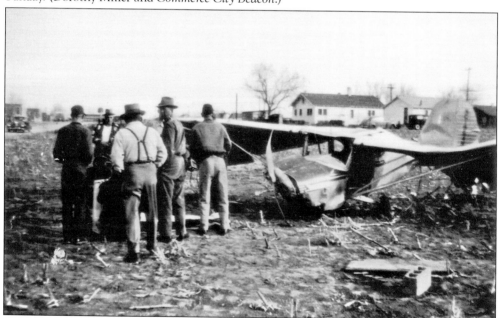

An airport was located in the 1930s in Dupont near the current location of the Dupont Post Office, around Seventy-sixth to Eightieth Avenues and old Brighton Road. The *Rocky Mountain News* called it the Dupont Airport, but in 1947, according to local telephone operator Bobbie Crall, it was listed at the Hazeltine Telephone office as Adams City Airpark. Other residents recalled that the airport was called Rutlidge Field. The airport was dismantled in 1954. (Iris Scadden.)

Here is a picture of the Derby Skating Rink, located at East Seventy-second Avenue and Locust Street. The skating rink was established in the late 1920s. It burned down on June 17, 1939, but was rebuilt and later used as Karls Shoe Store and later an auction house. It was razed in the late 1980s. (Dorothy Miller and *Commerce City Beacon*.)

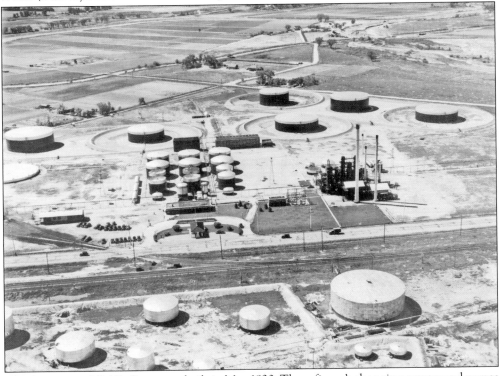

The Continental Oil Refinery was built in May 1930. The refinery's changing owners and names through the years included Bay Petroleum, Tenneco, King Resources, Asamera Oil, Total, Ultramar, Diamond Shamrock, Valero, and Conoco. A refinery explosion in 1978 could be felt as far away as what is now known as Centennial, Colorado. The damage was extensive, but the plant was rebuilt and improved. (Denver Public Library, Western History Collection, Call No. X-24471.)

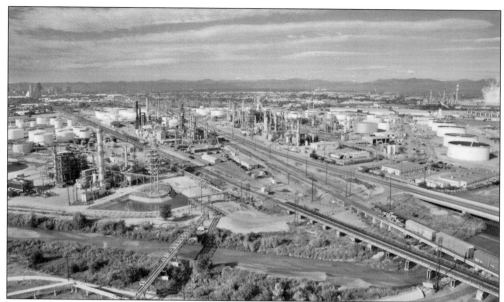

Suncor Energy was the only refinery in Colorado and the largest in the Rocky Mountain region, producing 93,000 barrels per day in the early 21st century. Suncor purchased the west plant in 2003 and bought the Valero refinery in 2005, marking the first time in history that a single company operated the refining assets on both sides of Brighton Boulevard. The refinery includes the east and west plants, called Plant One and Plant Two, with a new Plant Three. (Photograph by Jim Blecha.)

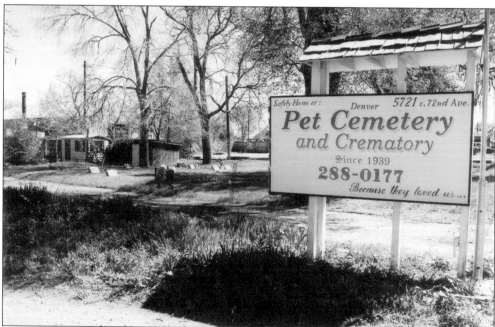

Pictured here is the Denver Pet Cemetery, located at 5721 East Seventy-second Avenue. Founded in 1939, it was first located at approximately Twenty-sixth Avenue and Walnut Street in Denver. It was moved to Commerce City in the early 1940s, when the government needed the Walnut Street land for the World War II effort. Bob Bass is currently the 21st-century owner. (Bob Bass.)

Sergeant Geronimo, part German shepherd and part coyote, is pictured with his owner, paratrooper Ken Williams. Geronimo was buried at the Pet Cemetery in 1947. A famous enlisted jumping mascot for the 507th Parachute Infantry during Word War II, Geronimo was named a sergeant by Pres. Franklin Roosevelt. Geronimo was killed by a hit-and-run driver on Race Street in Denver in May 1947. Ken Williams died in 1980. (Bob Bass.)

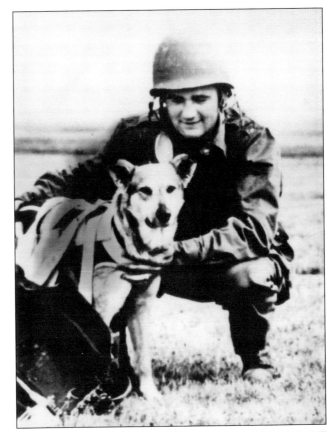

Big Ed's Tavern was one of the first businesses located on the arsenal land. In 1942, it moved to its present location at 6141 Olive Street. (Photograph by Debra Bullock.)

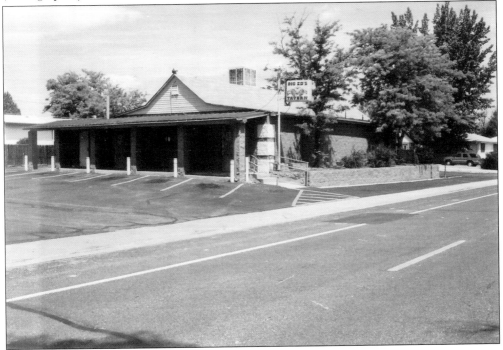

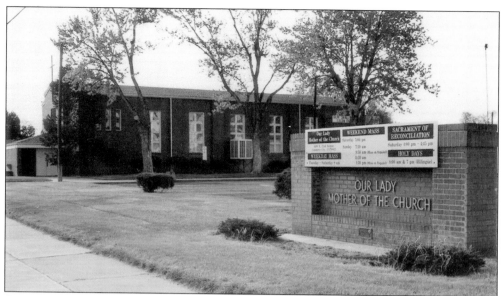

Our Lady Mother of the Church, located at 6690 East Seventy-second Avenue, began as a mission church in 1945 and was named St. Catherine's Catholic Church, dedicated on August 19, 1949. In 1952, the first Derby Fair was held in the church parking lot. A new church was dedicated in 1970, when the name changed to Our Lady Mother of the Church. In 1974, the church burned, but by December of that year it was rebuilt. In 1992, the last Derby Fair was held. (Charlene Jaramillo.)

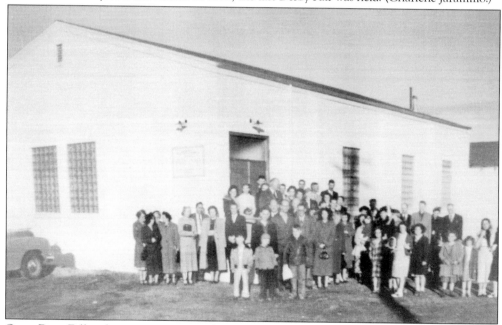

Open Door Fellowship was incorporated as Rose Hill Baptist Church in 1949 at 6650 Monaco Street. The congregation changed names first to First Baptist Church of Derby in 1955, then to First Baptist Church of Commerce City in 1964 after moving to 6690 Monaco Street, and finally to Open Door Fellowship in 1992. The congregation bought land at 14150 East 104th Avenue for a new church in 2007 and is currently worshipping at Turnberry Elementary School until the new church is built. (Dorothy Hutchings.)

The Mile High Kennel Club opened in 1949 and became one of the nation's main greyhound racing venues and the center of entertainment in Commerce City until it converted to a satellite betting–only operation in 2008. Community activities held at the Mile High Kennel Club included Adams City High School graduations once the ceremonies outgrew the school's indoor facilities. (Photograph by Debra Bullock.)

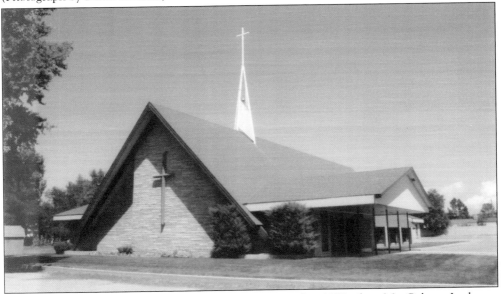

Our Saviour Lutheran Church was conceived in November 1950 when Mt. Calvary Lutheran Church at Thirty-sixth Avenue and York Street in Denver organized a branch Sunday school in the Derby area, held first in the Derby Roller Skating Rink and later in Derby School. In 1954, the group organized into a congregation and adopted the name Our Saviour Lutheran Church of Derby, Colorado. Herb Hast and Reverend Meyer purchased 5 acres at 6790 Monaco Street for a church. In 1955, a parsonage was built and used for services and Sunday school until 1957, when a new church was built at 6770 Monaco Street. The current church, pictured here, was built in 1963. (Our Saviour Lutheran Church.)

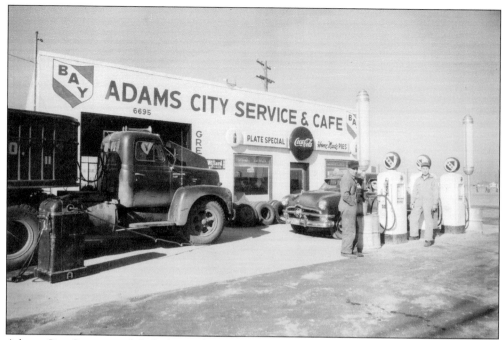

Adams City Service and Café, located at 6695 Brighton Road, was established in 1950 by Jake and Jenny Riggi. Later their two sons, Jake and Bobby Riggi, managed the business. Currently Lisa Riggi, granddaughter of Jake Riggi, owns and manages the business, making it one of the oldest businesses in Commerce City. (Lisa Riggi.)

These Quonset huts were moved from Fort Logan to Commerce City in the early 1950s. They are currently located at Sixty-third Avenue and Monaco Street. (Photograph by Debra Bullock.)

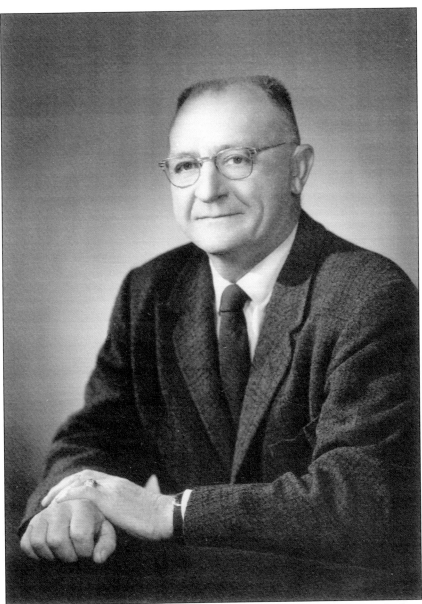

Alfred Krogh was the first mayor of Commerce City. In the 1950s, schools were built at a rapid rate, the police department was formed, and the South Adams County Water and Sanitation Department came into being. In 1952, Denver discussed annexing southern parts of what became Commerce City; residents felt it was time to incorporate. Herb Hast Jr. got into the act. A young schoolboy then, he rode his pony delivering notices of the meeting held in the McCoy Caterpillar showroom (Walmart land in the 21st century). Attended by 300 people, the meeting was chaired by Herb Hast Sr. The vote was in favor of incorporation, creating Commerce Town on December 12, 1952, with Krogh as mayor. He served from 1952 to 1965 and continued on the city council for three more years. He served on the Adams County Board of Adjustment for 40 years. A founding member of the South Adams County Fire Department, he also sat on the School District 14 Board of Education. Krogh Field House at the high school was named after Al Krogh in 1961. (Shirley Krogh-Leeper.)

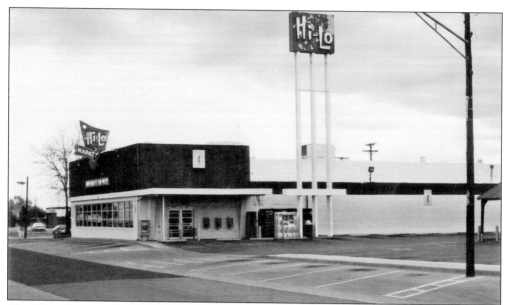

The Hi-Lo Supermarket building, located at 7290 Monaco Street, has housed three different food stores. The first was Busley's in 1953, then the Red Owl in the early 1960s, and Hi-Lo in 1965. The original Hi-Lo store was owned by Stanley Thompson and was located by the succeeding Ben Franklin store. Thompson purchased the Red Owl building in 1965 and sold the business to the Hi-Lo Employees Incorporation, including Wes Johnson, John Gilman, and Mark Learned, as well as other stockholders. (Photograph by Debra Bullock.)

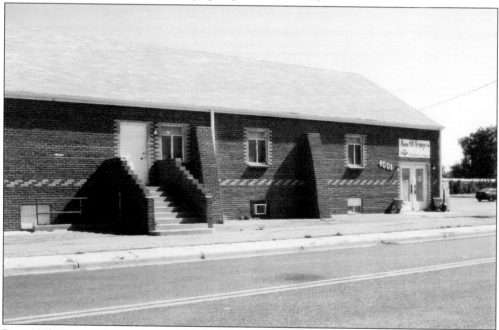

Rose Hill Grange No. 256 began on July 7, 1917, in the Rose Hill Schoolhouse on what is now arsenal ground. Later Rose Hill Grange moved to Adams City High School and then to Irondale School. In 1953, the grange built its hall at 4001 East Sixty-eighth Avenue. The building was dedicated in 1954. (Photograph by Debra Bullock.)

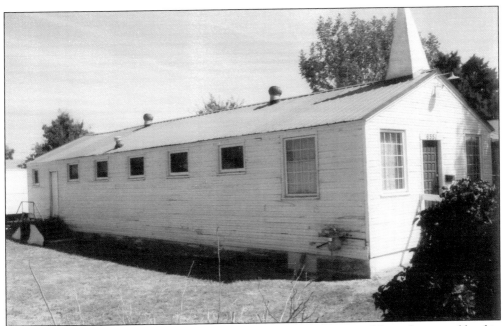

Ernest Mott rented this building in 1958, a Quonset hut that was moved from the arsenal land in 1942. In 1960, Mott purchased the building and land of four lots. This building was a furniture store and a pool hall before Mott purchased it. The Mott family established the Philadelphia Church and Mott's grandson, Ernest Phipps, is the pastor of the church. It is located at 6551 East Seventy-second Avenue. (Photograph by Debra Bullock.)

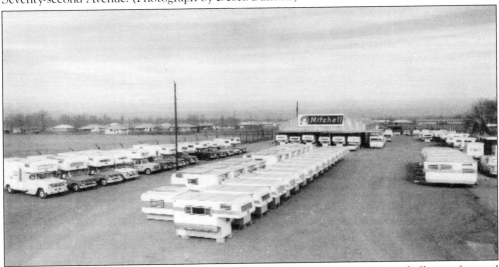

Mitchell and Sons moved from Henderson to Sixty-fourth Avenue in 1960. Mitchell manufactured and sold recreational vehicles until 1980, selling more RVs than any other place in Colorado. The travelling Big Horn Caravan, comprised of Mitchell Campers owners and friends and family, were greatly responsible for the success of the business. Mitchell and Sons celebrated their 50th anniversary in 2008. Mitchell and Sons currently does business as the Deck Superstore with the third Mitchell generation, brothers David and Steve, and fourth generation, Jonathon and Tim, in charge. The founders were Harry Sr. and sons Harry Jr. "Mitch" and Charles Russell "Bud" Mitchell. (Mitchell family.)

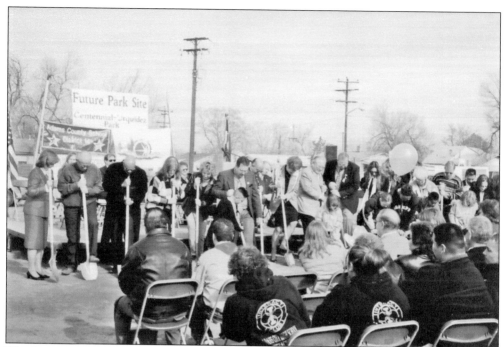

The Commerce City Rotary Club was chartered on May 9, 1961, changing its original name from Commerce Town Rotary Club in 1962. The officers for the 1961–1962 term were Alfred Krogh, president; Floyd Templeton, vice president; Guy Johnson, secretary; Art Towers, treasurer; and Howard Reidy, sergeant at arms. The club raises money for scholarships, children's programs, and the Christmas Island program. Pictured are local officials and rotary members at the groundbreaking of Urquidez Centennial Park in 2005. (Reba Drotar.)

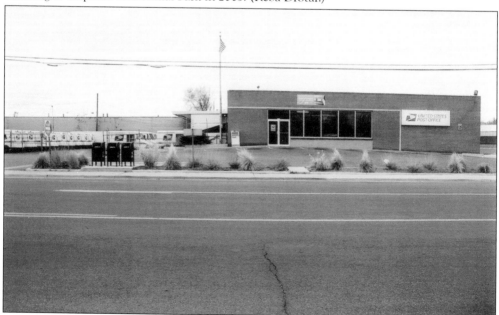

The first Commerce City Post Office, located at 7351 Magnolia Street, opened on February 2, 1963. The postmaster was Floyd Templeton. (Photograph by Debra Bullock.)

The Commerce City Memorial Day Parade has been a tradition in Commerce City since 1964 and has grown to be one of the largest parades in the state of Colorado. The first parade started at Seventy-second Avenue and Quebec Parkway, headed west on Seventy-second Avenue to Magnolia Street, and then north on Magnolia until it ended at the bank. Today the parade starts at Sixty-fourth Avenue and Olive Street and ends at the Commerce City Recreation Center. (Photograph by Debra Bullock.)

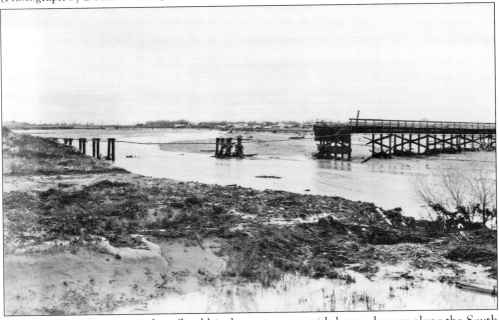

On June 19, 1965, a tremendous flood hit the metro area with heavy damage along the South Platte River in the Commerce City area. (Lt. Chuck Sauniers.)

In the 1960s, the town really began to grow up and changed its name to Commerce City in 1962. In 1967, Commerce City government moved into its new city hall/library at 5291 East Sixtieth Avenue. Prior to its building, all city offices were housed in a converted army barracks building at 6015 Forest Drive, just north of the new location where the playground now sits on the City Park land. (Laura Bauer, City of Commerce City.)

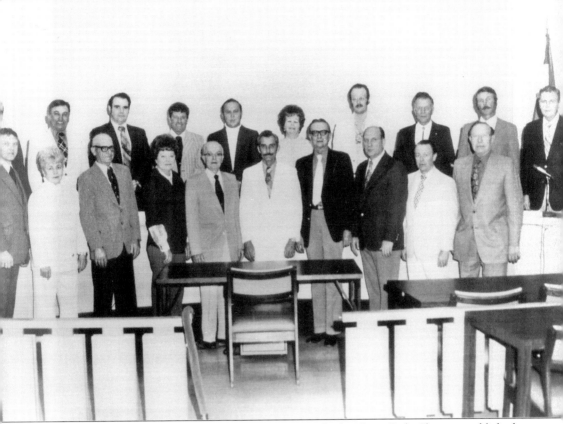

On May 5, 1970, the charter for Commerce City was formed. The Home Rule Charter established a council-mayor form of government. Harold Kite was elected mayor with 20 charter members and one attorney. Depicted is the 20th anniversary of the charter. Shown here, from left to right, are (first row) Bob Gehler, Margie Christiansen, Al Krogh, Sybil Ratcliffe, Al Williams, Harold Kite, Floyd Templeton, Ivan Jergensen, E. E. Casey Hayes, and John Roebuck; (second row) Roland Russell, Richard Vigil, Warren Kerls, Bob Calvert, Harry Tate, Jean Klein, Laverne Franzen, Leroy Fields, Leo Younger, and Dale Graham. Not pictured are Charles W. McCune and Larry Ford. As of September 2009, the living members from the charter commission were Bob Gehler, E. E. Casey Hayes, Warren Kerls, Bob Calvert, Jean Klein, Laverne Franzen, and Larry Ford. Klein passed away on December 16, 2009. (City of Commerce City.)

Pictured here is Mayor Harold E. Kite, the longest-serving mayor of Commerce City. The first mayor of Commerce Town was H. Alfred Krogh (1952–1965). Following him in succession were Ivan R. Jergensen (1965–1966), Leroy W. Fields (1966–1968), Eli L. Koff (1968–1970), Kite (1970–1975), Allen L. Williams (1975–1978), Kite (1978–1987), David R. Busby (1987–1999), E. E. Casey Hayes (1999–2003), Sean L. Ford (2003–2007), and Paul Natale (2007–present). (Photograph by Debra Bullock.)

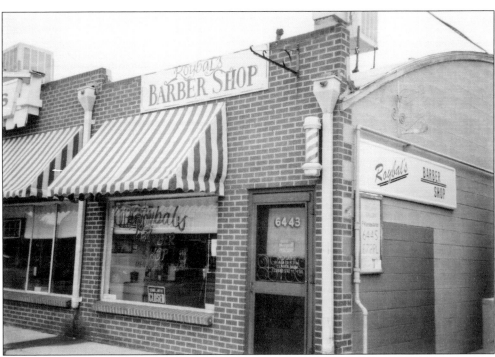

Pictured is Roybal's Barber Shop, located at 6443 East Seventy-second Place. The current owner is Joe Roybal; he has been at this location since 1973. Before Roybal purchased the shop, there were several owners through the years since the early 1930s. (Photograph by Debra Bullock.)

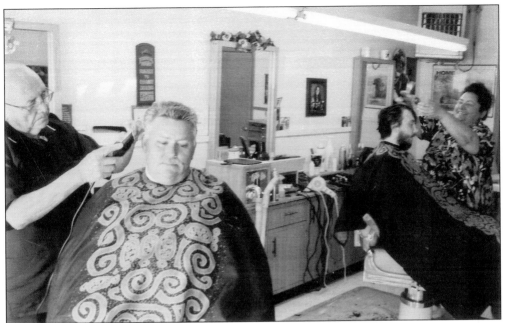

Here are Freeman David Chambers (left) and his son Michael Chambers in the barber chairs; standing are Joe Roybal and Jeanette Roybal. This family has been getting haircuts at Roybal's for four generations. David's father, Freeman P. Chambers, used this barbershop, and now David's grandsons, David and Andrew Chambers, get their haircuts at Roybal's Barber Shop. (Photograph by Debra Bullock.)

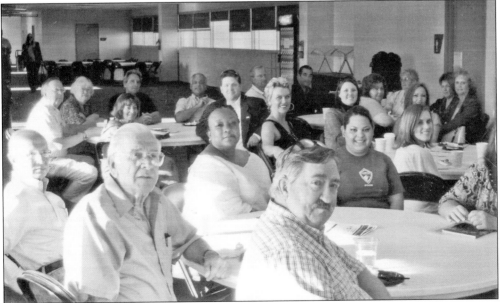

Pictured is the Commerce City Business and Professional's Organization during a meeting. The organization was started as the Commerce City Merchant's Association in 1976 by a group of residents. Mel Wolfe, from Wolfe's Sporting Goods, was the first president. Some founding members were Bryce Gregory, Harlow and Shirley Leeper, and Al and Jean Klein. The current president is Jim Byrds. (Photograph by Debra Bullock.)

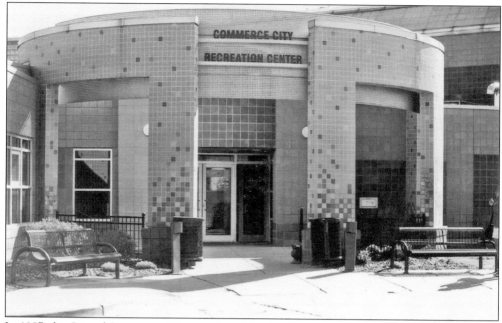

In 1987, the City of Commerce City purchased land at Sixtieth Avenue and Parkway Drive and built a state-of-the-art recreation center, which includes a senior center, swimming pool, gymnasium, weight room, exercise room, racquetball courts, meeting rooms, and more. The center has won awards for the outstanding building and services. (Photograph by Debra Bullock.)

David Busby was mayor of Commerce City from 1987 to 1999. Mayor Busby worked closely with the South Adams County Water and Sanitation District and represented the city in meetings concerning contamination issues at the Rocky Mountain Arsenal. Busby made nearly 50 trips to Washington, D.C., for meetings with the Department of Justice, the Environmental Protection Agency, and other agencies. Busby, who also negotiated the annexation of Denver International Airport lands, retained the honorary "mayor" after his term was over. (South Adams County Water and Sanitation District.)

The Derby Plain Janes are meeting here at the home of Bobbie Crall on September 4, 1996. They began as a Home Demonstration Extension Club, a local group of nationally organized clubs instigated in 1899 by Ellen Richards, a chemistry instructor at Massachusetts Institute of Technology. The purpose was to apply science to household problems. The American Home Economics Association was an outgrowth, founded in 1909, dedicated to improving living conditions. Home Economics Extension Clubs proliferated during the Depression, applying methods and research regarding nutrition, clothing, and child care to struggling homemakers' issues created by the poor economy. Each county had a representative who went to the monthly club meetings, where the projects included sewing, making clothes, canning, and gardening. Three Home Demonstration Extension Clubs once existed in this area. (Dorothy Miller and *Commerce City Beacon*.)

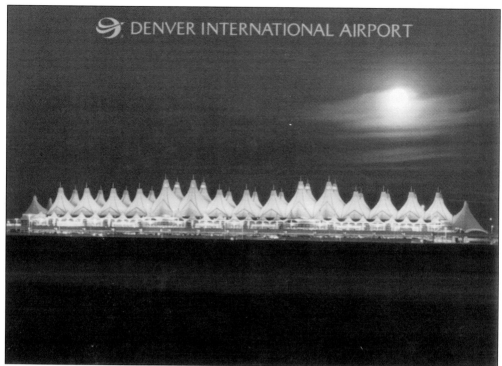

In 1988, the City of Denver paid $6.5 million to Adams County for 53 acres for the location of Denver International Airport. The airport was originally scheduled to open in 1993, but with construction delays and budget overruns the opening dates were extended. The airport opened in 1995. (Denver Department of Aviation.)

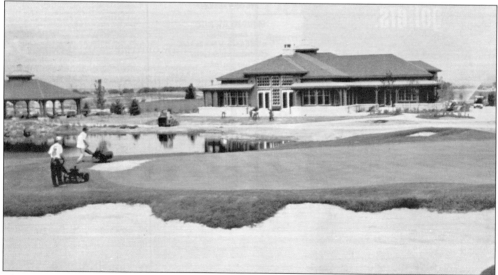

The Buffalo Run Golf Course opened in August 1996. The land was donated by Cal Fulenwider, Russ Watterson, John Fair with Northwoods Village Associates, and Gorden Mickelson with Moore and Company. The architect was Keith Foster for the front nine, and the project manager was Rob Thames with Commerce City Parks and Recreation. (Norm and Janet Union, *Commerce City Beacon*.)

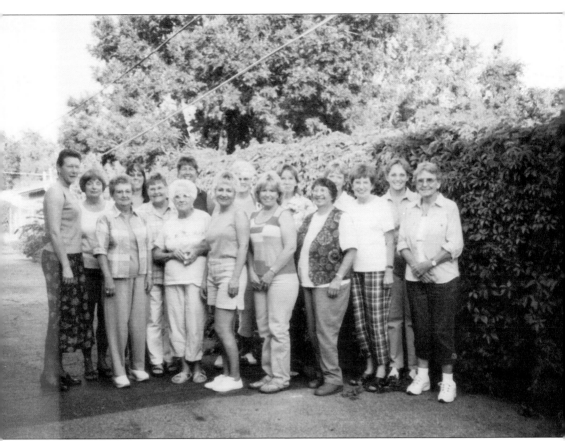

In June 1997, Shirley Leeper organized the South Adams Women's Association, which committed to volunteer community service and charities that have included book donations for third graders, fund-raising for the Northeast Emergency Catholic Charities Food Bank, Christmas gift and toy donations, and scholarship funding. Charter members of this organization were Shirley Leeper, Lynn Bradley, Pam Meier, Violet Stepanich, Lois Kimmes, Cathy Crookham, Janet Mishoe, Jean Klein, Lois Litsey, Wendy Talley, Lisa Lessard, Betty Pepin, Winnie Jergensen, Norma Russell, Marge Lambeth, Marlene Goettleman, Reba Drotar, Sue Kyger, Betty Martin, Janet Union, and Janice De Luzio. The 2005 members are depicted here. (Photograph by Debra Bullock.)

This is the 2003–2005 city council that is referred to often as "the council that changed Commerce City." Pictured from left to right are Tracey Snyder, Debbie Mitchell, Mayor Sean Ford, Orval Lewis, Scott Jaquith, Rene Bullock, Tony Johnson, Reba Drotar, and Kathy Teter. (Photograph by Debra Bullock.)

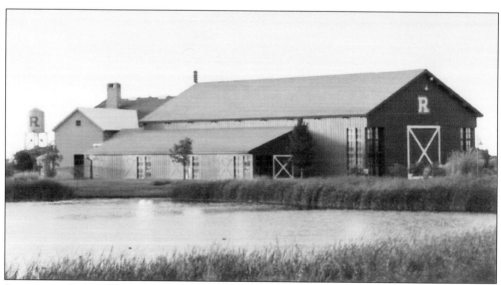

Starting in the late 1990s, expansion north of Ninety-sixth Avenue began and doubled the size of the city by 2009. The first development was Eagle Creek in 1999. Other developments include Belle Creek, Fronterra Village, North Range Village, Reunion, Turnberry, and many more. Pictured is Reunion, located on 104th Avenue from Chambers Road to Tower Road. (Kathy McIntyre and Karl Emmerick, the *Gateway News*.)

In 2002, the city purchased land at Sixtieth Avenue and Monaco Street and built the Pioneer Park and ball fields. The land was owned by the Conter family and willed to the Little Sisters of the Poor after Mrs. Conter's death. In 2004, Pioneer Park phase one was completed, and in 2008 phase two was completed. The city also has a July Fourth fireworks display, which is currently one of the largest in the state. (Photograph by Debra Bullock.)

In 1999, fearing the loss of funding for the arsenal cleanup and demanding that 917 acres should belong to Commerce City, activist Reba Drotar petitioned the U.S. government on the city's behalf. Supported by Kathy Teter and Larry Ford, and signed by hundreds of individuals and groups, Drotar's petition was delivered to the Pentagon on March 11, 2002. The property sale occurred on July 22, 2004, for $4.7 million, and the Prairie Gateway was born on March 25, 2005. Pictured are Commerce City citizens surrounding Ed Lucas, a former landowner on the arsenal. (Reba Drotar.)

Pictured here from left to right are John McCuskey, Thornton mayor Noel Busck, Reba Drotar, and Ed DeLozier at the opening of the final segment of the E470 Highway Authority on January 3, 2003. It unlocked the entire northern range of Commerce City and changed the transportation corridors forever. (Reba Drotar.)

Pictured from left to right are Reba Drotar and Tracey Snyder, council members; Al Klein; Pat Greer; Jean Klein; Kathy McIntyre; Perry VanDeVenter, city manager; and Angela Kreutzer, school board member. They are at the groundbreaking ceremony of the soccer stadium and the city hall complex on September 29, 2005. (Reba Drotar.)

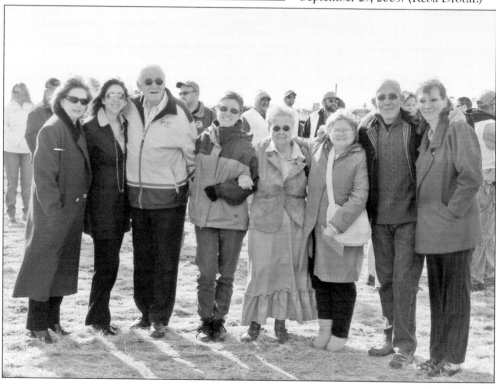

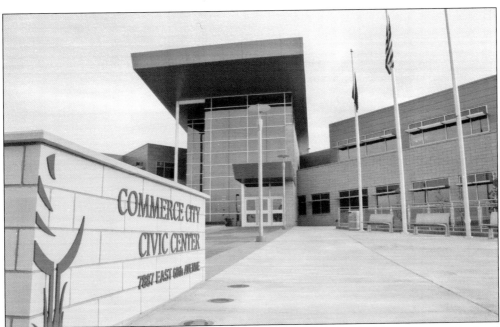

The new Commerce City Civic Center, located at 7887 East Sixtieth Avenue, opened in April 2007. (Laura Bauer, City of Commerce City.)

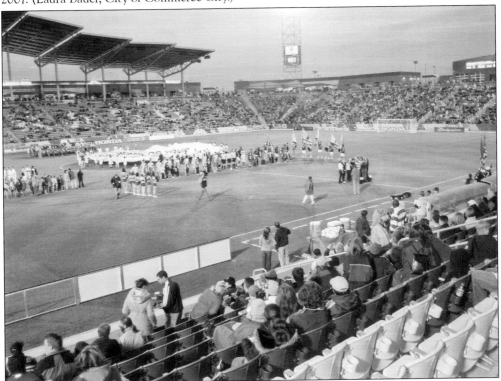

Dick's Sporting Goods Park is home to the professional Major League Soccer team, the Colorado Rapids. At this stadium-opening game on April 7, 2007, Commerce City residents were invited to participate at no charge. (Reba Drotar.)

Commerce City city manager Perry VanDeVenter (pictured here) and other 21st-century council members, including Mayor Sean Ford, were responsible for many new facilities in Commerce City. They were Pioneer Park, Conter Estates, development in northern portions of the city, conversion of 900-plus acres from the Rocky Mountain Arsenal (now the Prairie Gateway), the new city hall complex, Dick's Sporting Goods Park, Quebec Parkway, and Adams City High School. These changes led to a great population shift, from about 20,000 to more than 40,000 residents. (Reba Drotar.)

Margaret Swank was born in 1914 in St. Peter, Kansas. She married Milton Swank in 1941, and they moved to Adams City in 1947. In 1948, their home had to literally be cut in half to make way for the new Highway 85. The family built onto the back of the house when the highway frontage was condemned by the state. This home remains as the business Classic Realty. The Swank family owns many homes and businesses in the area, which their five children help manage. One of the children is Janet Union from the *Commerce City Beacon* newspaper. Milton Swank died in 1978. (Janet [Swank] Union.)

Pictured here are Denver Jr. and Erlea Black. Denver Jr. is the son of Denver Black Sr. Denver Jr. was born at home in Derby and still lives on the same block, 90 years later. He might well be the oldest person born and still living in Commerce City. The couple has two sons (Robert and Timothy), five grandchildren, and nine great-grandchildren. Denver Jr. took over managing Black's Garage in 1959. He sold it in 1992. (Denver Black; *Gateway News*.)

Bobbie (Arnold) Crall moved to Commerce City in October 1947, shortly after marrying Lincoln Crall. Their sons, Jim and John, graduated from Adams City High School. She worked at the Hazeltine Exchange Telephone Company from 1942 to 1947. Bobbie was the operator who transferred the last call on the switchboard before the company switched to the dial system. Hazeltine Exchange was located on Seventy-second Avenue, next to the Rainbow Bread Company. The phone company, then known as Mountain Bell (later AT&T), moved to Seventy-second Avenue and Highway 2. Bobbie has attended almost every city council meeting for more than 20 years. (Photograph by Debra Bullock.)

Ellis Elmo (Casey) Hayes moved to Commerce City from Iowa in 1952 and bought land on Sixty-sixth Avenue from Howard "Pro" Swanson and has lived there ever since. He married his second wife, Marianne, in 1963, and they had two children. When he moved to Commerce City, Hayes said there were no paved streets, no signs, no gutters, or sidewalks, but a lot of cornfields. In 1958, Hayes was one of the original members of the Tichy Subdivision Charter Commission and served four terms as the state representative for House District 32. He served on the Commerce City Council for many years, starting in 1960, and was mayor from 1999 to 2003. He also served on the Regional Transportation District Board (1983–1986). Hayes was a founding member of the Adams County Historical Society. Hayes collects vintage automobiles. (Casey Hayes.)

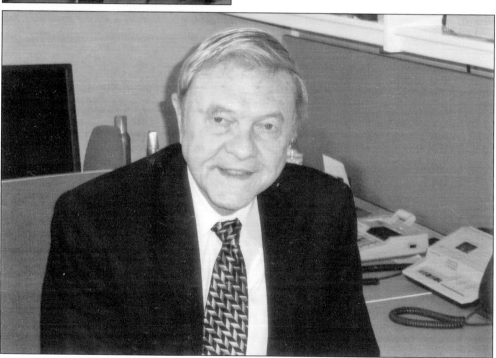

Pictured is the Commerce City attorney, Bob Gehler. He was the attorney for the Charter Commission in 1970 and has been working for the city since 1968. Gehler was born in South Dakota in 1936, graduated from law school in 1960, and was in the army from 1961–1964. He married his wife, Terri, in 1962. They have two grown children. Since 1965, Bob has had a law practice with partners and later his own law firm until 2006, when he became the full-time city attorney for Commerce City. (Photograph by Debra Bullock.)

Ann (Johnson) Emerson and her two brothers, Robert (sitting) and Jerry (standing), were born and raised in the Commerce City area. Their grandmother and her sister came from Sweden in 1888 and bought property on Fifty-sixth Avenue and Sixtieth Avenue. The family ran IXL Dairy and farmed the land. The dairy was operated from 1924 until 1954. The family still owns the homes on Fifty-sixth Avenue and Dahlia Street that were built in 1903 and 1938. Axel and Lilly Johnson were their parents. Ann still lives in Commerce City, Robert lives in Westminster, and Jerry lives in Denver. (Ann [Johnson] Emerson.)

Harlow and Shirley Leeper were born in 1930 and attended first grade through Adams City High School together, graduating in 1948. They married in 1952. Their three daughters also graduated from Adams City. Shirley's father and grandfather, Ed and Al Krogh, both hog farmers, were instrumental in the course of the school district and fire and water departments in Commerce City. Harlow was a volunteer fireman and was fire chief in 1963. He was on the water board and served as secretary for 24 years. He was also a community relations consultant for waste management for 10 years. Harlow and Shirley originated the Burn Fund in 1977 to benefit the Burn Unit at University Hospital. Shirley was a school teacher for several years. The Leepers have owned and operated Adams City Greenhouses, Leeper Realty, and Commerce City Floral and belong to many organizations. They retired to the northern area of Commerce City. (Photograph by Debra Bullock.)

Two

SCHOOL DISTRICTS 14 AND 27J

In the beginning, in 1871, School District 14 was a one-room schoolhouse supervised by one teacher. In 1899, another school was built. The district was 12 square miles and consisted of two schools: Sand Creek School in the southern area and Cook School on the north end. Both schools were sold in 1906.

A new school building was erected in 1916. In 1924, the first gymnasium and a few more classrooms were added. The original four-room brick school was remodeled in 1936. The belfry tower and high roof were removed when four classrooms were added on the north side. In 1939, the classroom section was built, and in 1941 a large gym (the girls' gym) was built. In 1946–1947, surrounding school districts consolidated to form Adams County School District 14. Union High School No. 1 became Adams City High School, with its athletic teams becoming the Eagles. In 1948, the football field was named Krogh Field after Ed Krogh, an early pioneer.

During the 1940s and 1950s, the period when Commerce Town was established (in 1952), the district built seven elementary schools and two middle schools. By the 1970s, Adams County District 14 had nearly 800 employees, 11 schools, and an enrollment of nearly 7,000 students.

In the 1980s and 1990s, the school district developed the first AIDS education curriculum in the state, integrating special needs students into the classroom, placing child advocates in every school to address psychosocial issues, and creating after-school programs. Adams 14 put computers in every classroom.

School District 27J opened schools within the northern land boundaries of Commerce City in the 21st century.

School District 14 had 945 employees in 13 schools and one charter school had an enrollment of nearly 6,900 students in 2009. The last graduating class from Adams City and current Lester Arnold High Schools was 312 students. The new Adams City High School, located at 7200 Quebec Parkway, was built in 2008–2009 and opened for the school year of 2009–2010 in August 2009.

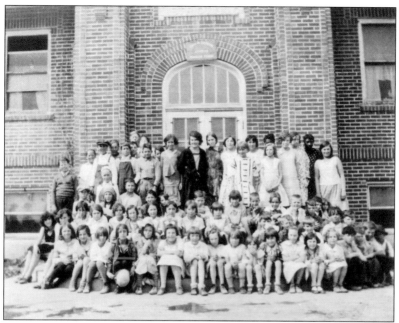

The first grammar school was built in 1906. A four-room brick schoolhouse sits in the middle of the prairie at the present location of Sixty-ninth Avenue and Cherry Street. Eight grades are divided among three of the four rooms. Pictured here is Adams City Elementary. (Dorothy Miller and *Commerce City Beacon*.)

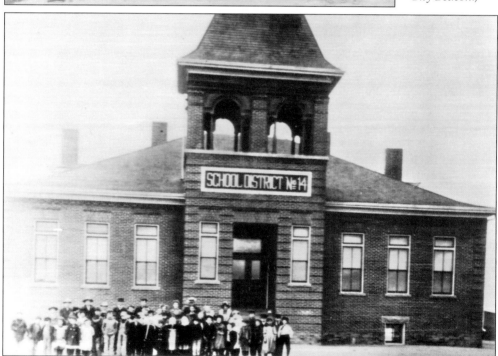

This is Union High School. By 1908, Union High School No. 1 of Adams County was formed in the fourth room of the four-room schoolhouse, which included the areas of Adams City, Derby, and Rose Hill. Basketball was the first sport at Union High School, and it started in the 1910–1911 season. No regular games were played the first year, but the following years games were played at Brighton and Fort Lupton. The first graduating class from Union High School No. 1 was in 1910. There were two graduates, Marian Andrew and Edward Cook. (Dorothy Miller and *Commerce City Beacon*.)

Irondale School, located at 8702 Rosemary Street, was established in the early 1900s. The school closed in 1980. It then became the headquarters for the Denver Gold football team from 1981 to 1983. It is now a church home for the Iglesia Independiente congregation. (The Denver Public Library, Western History and Genealogy, Call No. Z-10747.)

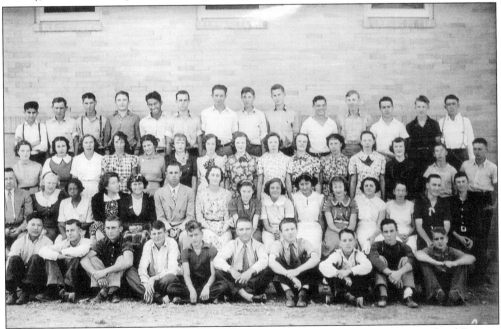

Pictured are students from Adams City High School in 1937. In 1946, Adams City School District 14 became Adams County School District 14. The football field and stadium were built in 1946. In 1953, the grade school moved to a one-story building east of the high school, and a separate building for music and shop classes opened. (Dorothy Miller and *Commerce City Beacon*.)

The Derby school was built in the early 1900s at East Seventy-second Avenue and Monaco Street on the west side of Monaco Street. It was razed in the mid-1970s, and the current library was built and opened in 1977. The second Derby Elementary (pictured here) was built in 1953 on the east side of Monaco and later became Lester Arnold High School at Seventy-second and Monaco. (The Denver Public Library, Western History and Genealogy, Call No. X-7691.)

This is Lester Arnold High School, founded by Lester Arnold. The school is located at 6500 East Seventy-second Avenue. Lester Arnold was a principal and administrator in School District 14. (Photograph by Debra Bullock.)

50

HOMECOMING DINNER

AND

DEDICATION PROGRAM

in honor of

EDWARD I. KROGH

ADAMS CITY, COLORADO **OCTOBER 1, 1948**

On October 1, 1948, the football field at Adams City High School was dedicated to Edward Krogh, an early pioneer. Krogh was born in Denmark, Sweden, in 1870 and came to Colorado in 1893 with his family. He moved to the Adams City area in 1908, where he established his hog ranch. He served on the School District 14 board and promoted building a sports field at the high school. He and wife, Kristina, had four children, three of whom were well-known citizens of the community: Eleanor Hansen, Lela Juhl, and Alfred Krogh. Third-generation family members are also well known in the community. The board of education in 1948 consisted of D. B. Alsup, president; Alfred Krogh, treasurer; Floyd Templeton, secretary; Ward Kemp; and H. Vance Deakin. The superintendent was Warren B. Fitzsimmons. (Shirley [Krogh] Leeper.)

Shown here is the Adams City High School as it stands today. This high school served the Commerce City area for over 100 years. Many changes and additions have taken place over the last century, and memories will forever be with all the students, teachers, and administrators that passed through the halls of this school. (Photograph by Debra Bullock.)

In 1961, Krogh Field House and the swimming pool were built and named after Alfred Krogh, former mayor and school board member. (Photograph by Debra Bullock.)

Two junior high schools built in the early 1950s were Adams City Middle School (pictured), located at 4451 East Seventy-second Avenue, and Kearney Middle School, located at 6160 Kearney Street (built in September 1953). (Photograph by Debra Bullock.)

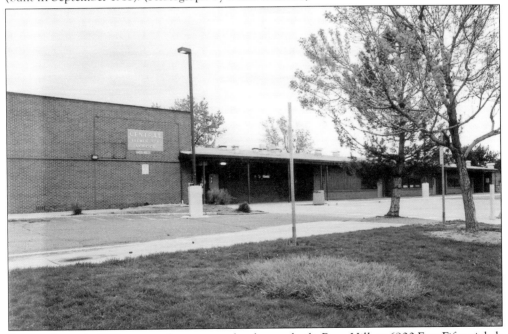

During the early 1950s, many elementary schools were built: Rose Hill, at 6900 East Fifty-eighth Avenue; Hanson (formerly Oneida), at 7133 East Seventy-third Avenue; Dupont, at 7970 Kimberly Street; Central (pictured), at 6450 Holly Street; and Monaco, at 7631 Monaco Street. (Photograph by Debra Bullock.)

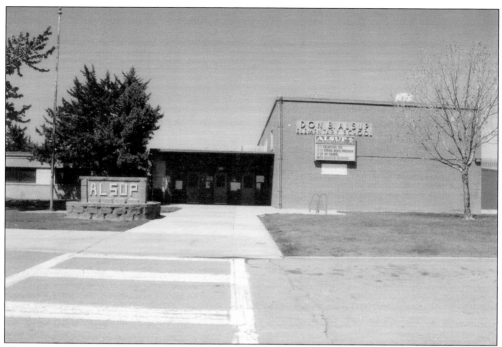

The last two elementary schools to be built in District 14 were Kemp Elementary, named after Ward Kemp, and Alsup Elementary (pictured), named after Don B. Alsup, both former school board members. The schools were built in 1959. Kemp Elementary is located at 6775 Oneida Street, and Alsup Elementary is located at 7101 Birch Street. (Photograph by Debra Bullock.)

There are two preschools located in Commerce City: Sanville Preschool (pictured) and Star 8 Learning Center, on Fifty-sixth and Bowen Court. Sanville was the first No. 2 Firehouse for South Adams County Fire Protection District, located at 5941 East Sixty-fourth Avenue. (Photograph by Debra Bullock.)

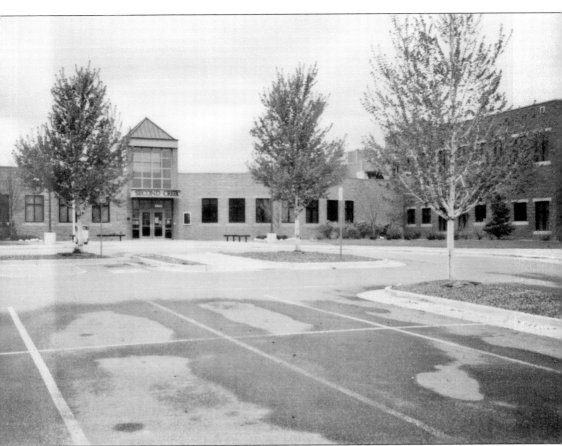

The first school to be built in the 27J School District within Commerce City was Thimmig Elementary in 2002. It was named after Dr. John W. Thimmig, a veterinarian in Brighton and the director of the 27J Board of Education from 1947 to 1963. The ground-breaking was on September 11, 2001, and the school opened in August 2002. Second Creek Elementary followed in August 2003. Turnberry opened in 2007 and was named after the local subdivision. Otho E. Stuart Middle School is located east of 100th Avenue and Chambers Drive and opened in 2009. Otho E. Stuart was an educator in School District 27J for 42 years. Pictured here is Second Creek Elementary School, named after Second Creek. (School District 27J historic records.)

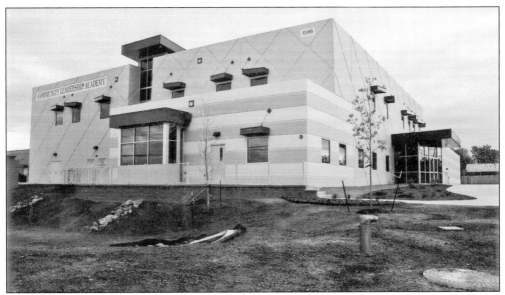

Charter schools started to establish in both School District 14 and 27J in 2003. Belle Creek, Brighton Collegiate, Bromley East, and Landmark Academy have opened in 27J. Community Leadership Academy has been established in School District 14. Pictured is the Community Leadership Academy located at Highway 2 and Sixty-ninth Avenue. (Photograph by Debra Bullock.)

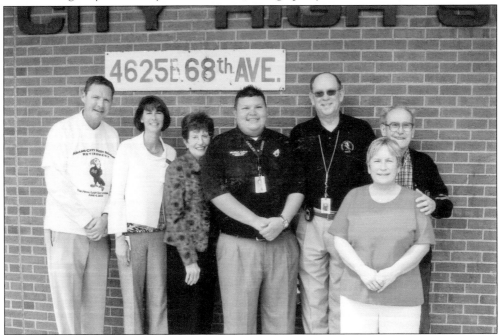

These are students, past graduates, and school administrators on the last day of school on June 4, 2009, at the ceremony of the Adams City High School closure. From Left to right are Wesley Paxton, principal; Sue Chandler, superintendent; Jeannette Lewis, School District 14 board president; Matt Lacrue, 2009 class president; Carroll Harr, vocational department director; Leonard Dietz, class of 1945 graduate; and Marvel (Dietz) Markin, president Union Alumni Association and also a past graduate of Adams City in 1966. (Photograph by Debra Bullock.)

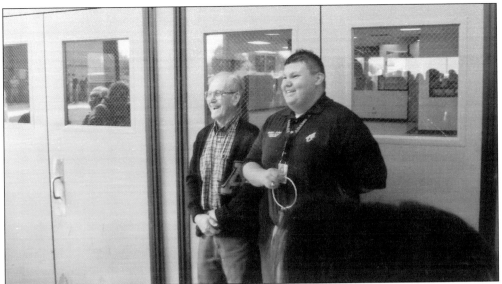

Pictured is Leonard Dietz, an Adams City High graduate from 1945, and Matt LaCrue, a graduate from the last graduating class at Adams City High School on Friday, June 4, 2009. This was the final closing of the school. Together they locked the doors after the students finished the last day of school. (Photograph by Debra Bullock.)

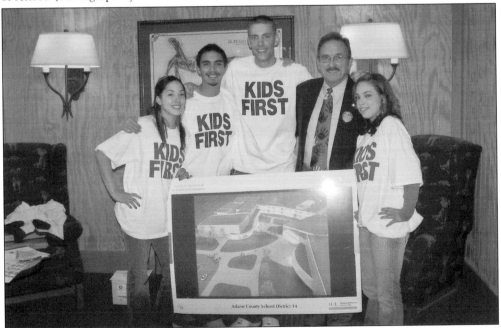

In June 1994, Dr. John Lange became the principal of Adams City High School. He then served as the Adams 14 superintendent from October 1998 to September 9, 2008. Credited with the vision of the new high school/community college, Dr. Lange received numerous local and national awards for the positive changes in the district. Beloved by students and community alike, he worked tirelessly to bring quality, well-rounded educational opportunities to all. Pictured from left to right are Christina Ford, David Rolla, Chris Loney, John Lange, and Resha Ford at the bond fund-raiser in 2005. (Richard Ford.)

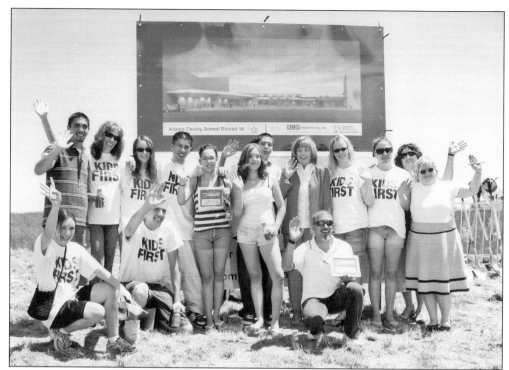

In late 2005, Mayor Sean Ford, Mayor Pro-Tem Rene Bullock, and council members Tony Johnson, Reba Drotar, Kathy Teter, and Tracey Snyder worked to donate 55 acres of the Prairie Gateway to build the first new high school in nearly 100 years. Dr. John Lange and student activists ("Kids First"), the Richard Ford family, the Angela Kreutzer family, David Rolla, Chris Loney, Amy Younger, and Kathy McIntyre of the *Gateway News*, led the successful bond campaign of November 7, 2006. (Richard Ford.)

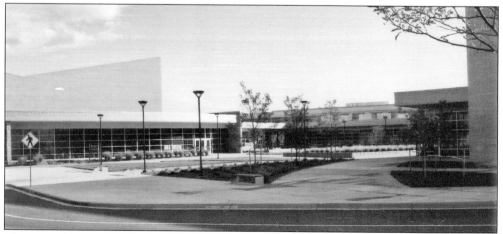

The new Adams City High School is built on 55 acres. The building is 293,000 square feet and has over 100 security cameras in place 24 hours a day, seven days a week, to monitor the building and campus. In November 2006, a $78-million bond election approved a new high school/community college campus. The ground-breaking was on May, 19, 2007, the ribbon cutting on July 31, 2009, and the opening of the school, located at Seventy-second Avenue and Quebec Parkway, was on August 13, 2009. (Photograph by Debra Bullock.)

Pictured is the current 2009 school board. From left to right are (seated) Robert Vashaw, Jeannette Lewis, and Larry Quintana; (standing) Jeff Smith and Bill Klocker. Dr. Susan Chandler is the superintendent (not pictured). (School District 14.)

Elsie Zetterman moved to Commerce City in 1949. She was born in Nebraska in 1916. Elsie worked as a teacher and retired after 32 years. She taught at Derby School and was a music teacher. Her favorite memories are the people from the school district and the children. She states that the traffic is one thing that she does not like, and the city is getting too large. (Esther Hall and Hester Bonnell.)

Lester and Mary Arnold came to Commerce City in 1951. Lester was the principal at Adams City High School from 1951 to 1968 and later a district administrator as director of secondary education and personnel, ending his career as acting superintendent and School District 14. In 1987, Lester Arnold High School opened. He was the grand marshal of the Memorial Day Parade in 2008. Mary Arnold worked at the Hazeltine Phone Company. Lester was born in Connecticut on May 4, 1919, and Mary (Maybury) was born in England on June 14, 1924. They were married on November 26, 1946, in Loveland, Colorado. Lester was in World War II in Europe, and Mary was an army territorial service person. They have one son named Bruce. They both miss the old neighborhood and the closeness of the neighbors. They both love the accomplishments made in the community. They still live in Commerce City. (Esther Hall and Hester Bonnell.)

Leonard Dietz was born and raised in Adams City. Carol moved with her parents from Denver to Adams City when she was in the eighth grade. Leonard graduated from Adams City High School in 1945, and Carol graduated in 1946. Carol's father, Carl Horblit, was the first fire chief for the fire department. They were married in 1948. Leonard worked for Mountain Bell Telephone Company for over 36 years, and Carol worked at the Adams City Post Office for 28 years. They have four children and four grandchildren. They are true Adams City pioneers. (Dorothy Miller and Commerce City Beacon.)

Three

EARLY FAMILIES AND THE ROCKY MOUNTAIN ARSENAL

The Rocky Mountain Arsenal was located in Commerce City, approximately 10 miles northeast of Denver's Colorado State Capitol building. In 1992, the former U.S. Army site was designated as the future Rocky Mountain Arsenal National Wildlife Refuge. The history of this 27-square-mile landscape can be traced back to early Native American peoples who were hunters and gatherers. From the 1850s to the early 1940s, this prairie was occupied by homesteaders.

In the 1940s, twenty thousand acres of this land was purchased by the U.S. government as a result of condemnation hearings. These lands became the Rocky Mountain Arsenal, a chemical weapons manufacturing center that supported the World War II campaign by producing wartime chemical munitions.

After the war, in the 1950s, the arsenal was reactivated in response to the Korean War. Shell Oil Company also began leasing facilities at the site in 1952 to produce agricultural chemicals.

In the 1960s, the manufacture of rocket propellants continued throughout most of the decade. By June 1962, a pressure injection disposal well was completed, which eventually pumped approximately 165 million gallons of treated waste material to a depth of more than 12,000 feet into the earth.

In the 1970s, the demilitarization of stockpiled munitions continued and containment of off-post migration of contamination became the arsenal's most pressing mission. In the 1980s, the army, Shell Oil Company, and the State of Colorado worked to clean up the site. In 1986, bald eagles were discovered at the site.

In 1992, the site was earmarked for a wildlife refuge after the cleanup had been completed. In 1994, the Restoration Advisory Board (RAB) was established. In 1996, the Record of Decision (ROD) was signed. This document outlines the overall cleanup actions at the site.

In 2003, more than 900 acres of land along the western portion of the site, which is now called the Prairie Gateway, were sold to Commerce City. Land transfers began in 2004 from the U.S. Army to the U.S. Fish and Wildlife Service, establishing the Rocky Mountain Arsenal National Wildlife Refuge.

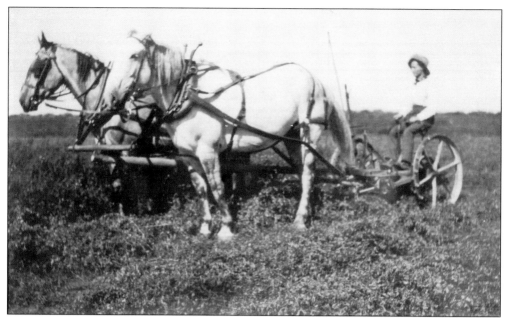

In the 1860s to the 1930s, over 200 families were farming on the Rocky Mountain Arsenal land. Family names like Mayberry, Maurer, Bollers, Telfer, Bax, Herskind, Egli, Lucas, and Anger farmed this land. Pictured is a member of the Anger family harvesting crops in the early 1900s. (Anger Family; U.S. Fish and Wildlife Service.)

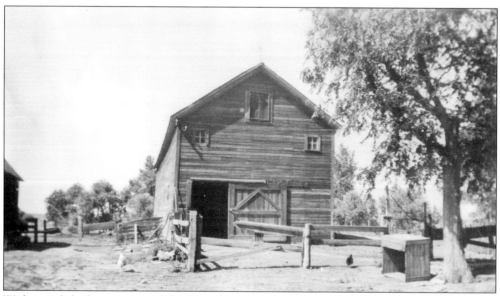

With its polished quarter-sawed flooring, the Anger family barn doubled as a popular dance hall in the off-farming season for neighbors and friends in the early 1900s. (Anger Family; U.S. Fish and Wildlife Service.)

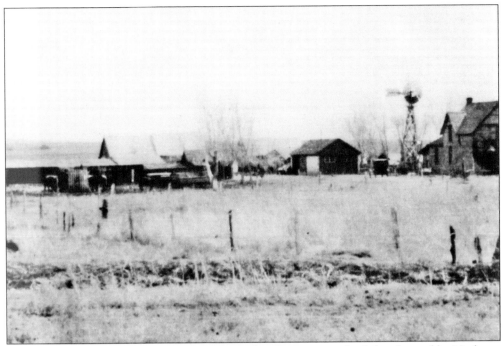

Thirteen Mayberry children were born and raised in this two-story brick farmhouse (the Mayberry farm, pictured here in 1920) that once stood near present-day Ninety-sixth Avenue between Potomac Street and Peoria Street. (Mayberry family; U.S. Fish and Wildlife Service.)

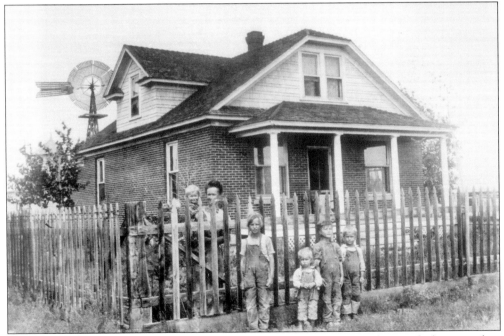

The Egli family home, pictured here in the 1920s, still stands as a historic tribute to the homesteading era. The building is included on the National Register of Historic Places waiting to be restored. (Egli family; U.S. Fish and Wildlife Service.)

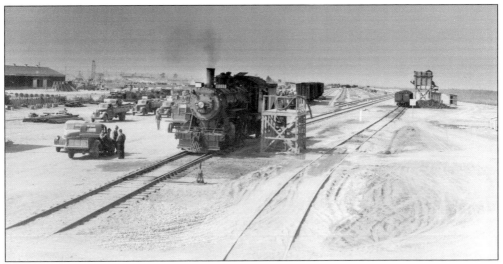

The U.S. Army chose the Rocky Mountain Arsenal site in Commerce City in part because of its water sources and proximity to established transportation routes, which included a connection to the Burlington Northern and Union Pacific rail lines. The land was centrally located in the United States and far removed from coastlines and, therefore, safe from enemy attacks. The arsenal maintained a railway within its boundaries. (U.S. Army.)

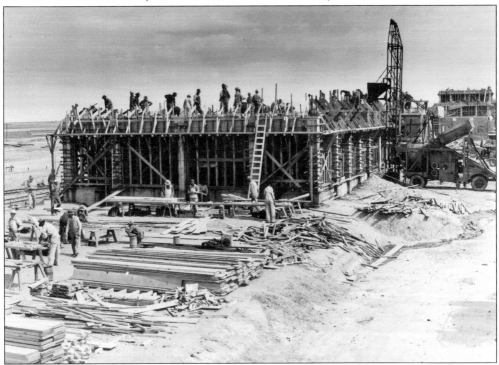

Due to the breakout of World War II, the construction of the arsenal began on June 30, 1942, with crews working around the clock to construct the chemical manufacturing complex. Six months after beginning construction, the first fully operational production building (South Plants) was activated a year ahead of schedule. A reason for the emphasis on speed was the fact that Germany already developed a chemical weapons program. (U.S. Army.)

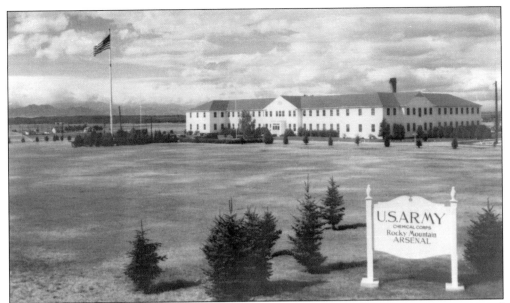

As one of the most recognizable buildings at the site, Building 111—or the "White House"—served for decades as the administration offices of the U.S. Army. (U.S. Army.)

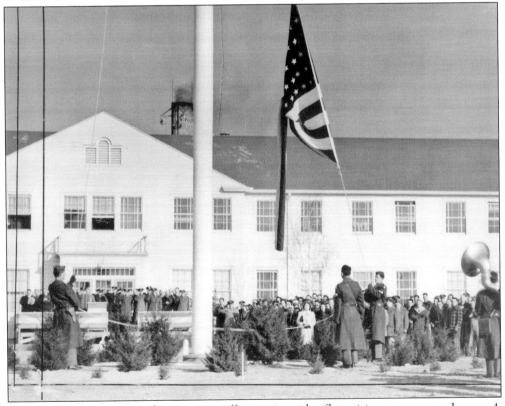

The U.S. Army opened its administration office on site with a flag-raising ceremony on January 4, 1943. The building remained the administrative hub of the Rocky Mountain Arsenal for decades. (Steve Nehf, the *Denver Post*.)

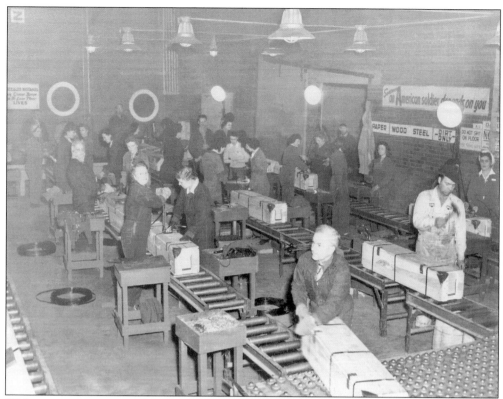

With many men overseas fighting in World War II, the army recruited women to produce and package weapons for the war effort. Between 1943 and 1945, nearly 3,000 employees worked at the arsenal around the clock, seven days a week. The arsenal completed its mission and was put on standby status in 1947. To avoid "mothballing" of the site facilities, some were leased to private companies such as Julius Hyman, which was acquired by Shell Chemical Company (later Shell Oil) in 1952. (U.S. Army and the Nagel family.)

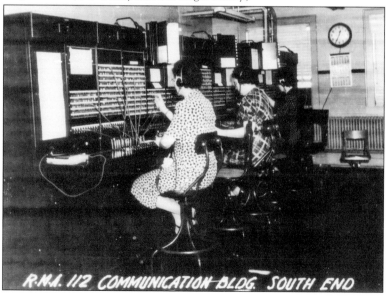

Roughly 70 percent of the arsenal's workforce in the 1940s included women, with many holding jobs outside the home for the first time. (U.S. Army.)

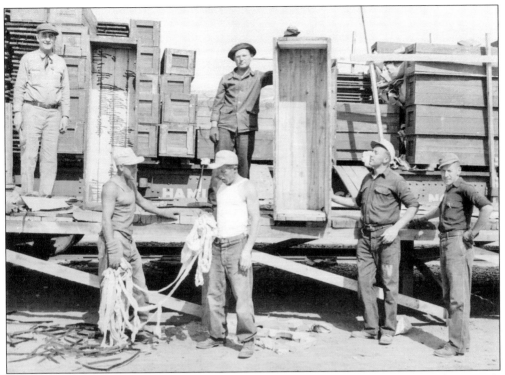

A prisoner-of-war camp was established on the Rocky Mountain Arsenal from November 6, 1943, until April 1, 1946, and held as many as 300 German prisoners. This camp was known as the Rose Hill POW Camp. (U.S. Army.)

This home served as the commander's quarters from the early 1950s until the mid-1970s, when it was torn down to make way for one of the Stapleton Airport runways. Approximately 3,000 acres of arsenal land was used to expand Stapleton. Another 1 square mile at Fifty-third Place and Quebec Parkway was sold to Denver for the post office complex. (U.S. Army.)

Maj. Paul Kelly constructed Lake Mary in the 1950s during his spare time as a place for children to fish. The lake is named after Kelly's daughter Mary and continues to be a popular spot for catch-and-release fishing and viewing waterfowl. (U.S. Army; Josh Barchers.)

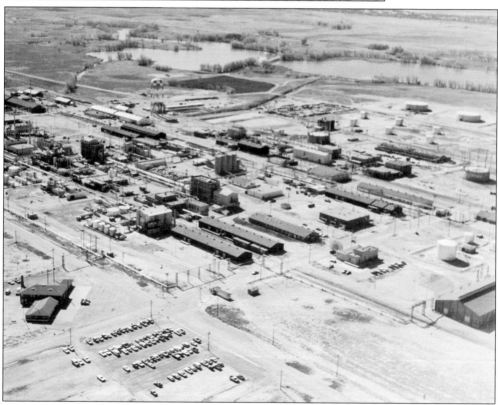

The South Plants manufacturing complex is seen here around 1960. Located near the center of the arsenal, the South Plants consisted of 295 structures built in the early 1940s for the production of wartime chemical weapons. From the beginning, three major war chemicals were made at the Rocky Mountain Arsenal: mustard gas, lewisite, and chlorine gas. Other varied munitions, including incendiary bombs, were manufactured at Rocky Mountain Arsenal. In 1952, Shell Oil Company became the primary commercial manufacturer at the South Plants, producing herbicides and pesticides until 1982. (U.S. Army.)

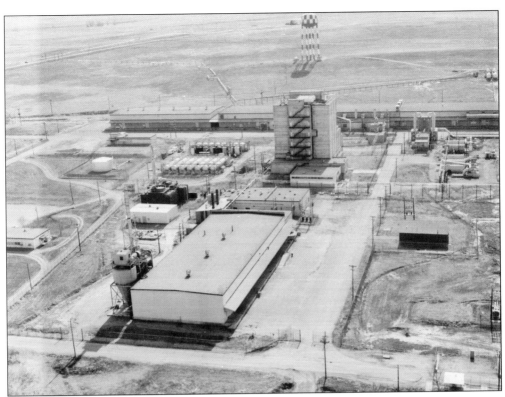

The North Plants manufacturing complex consisted of 90 acres and 103 structures built between 1951 and 1953 in response to the Cold War and the Korean War. The arsenal officially went back on wartime status and started manufacturing nerve gas in a once-secret installation between 1953 and 1957. (U.S. Army.)

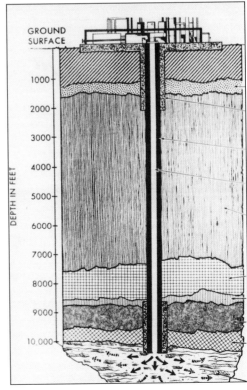

In 1965, a series of earthquakes rocked the Denver area. Some believed the quakes were caused by pumping arsenal liquid waste into a 12,000-foot-deep injection well. As a result, pumping activities stopped in 1966, and the well was permanently sealed in 1985. Decades of using accepted practices of the era to dispose manufacturing waste led to partial contamination of the site's soil, structures, and groundwater. (U.S. Army.)

Built in 1942, Officers Row consisted of five homes that housed arsenal officers and their families until the mid-1970s. (U.S. Army.)

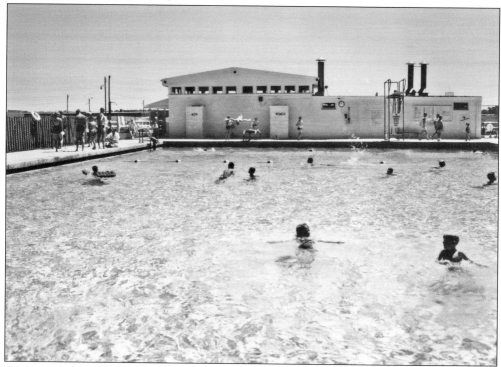

Army employees and their families enjoyed a swimming pool at the installation from the 1960s to early 1990s. (U.S. Army.)

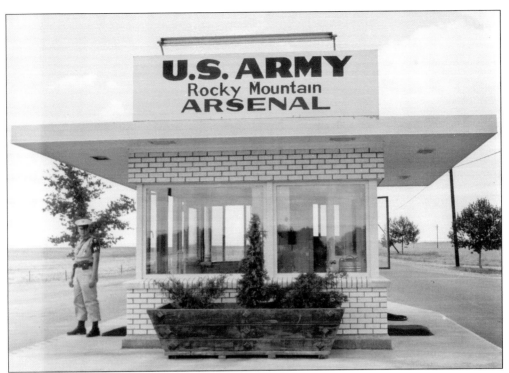

Rocky Mountain Arsenal's west gate entrance in the 1960s was located at Seventy-second Avenue and Quebec Street. The other locations for entering the arsenal were at Fifty-sixth Avenue and Havana Street and Ninety-sixth Avenue and Peoria Street. (U.S. Army.)

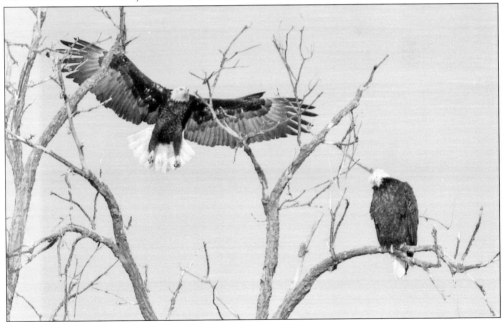

The discovery of the American bald eagle at the Rocky Mountain Arsenal in 1986 ultimately led to designating the site as a national wildlife refuge once cleanup was complete. (U.S. Army; Rich Keen.)

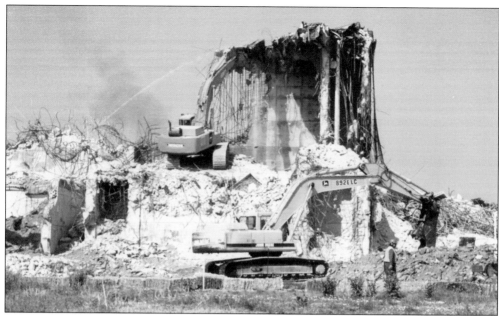

Rocky Mountain Arsenal crews demolished more than 400 structures as part of the comprehensive cleanup program. Through the years of the cleanup process, building debris and contaminated soil was placed in either the arsenal's on-site landfills or consolidation area. Currently more than 750 million gallons of groundwater is treated yearly at the arsenal's five groundwater treatment plants. (U.S. Army; Josh Barchers.)

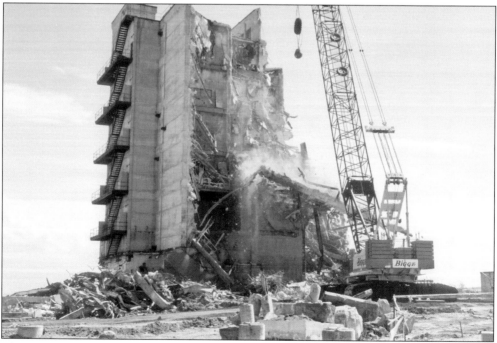

The Rocky Mountain Arsenal has received numerous workplace safety awards throughout the cleanup program and has been named one of the safest work sites in the country by the Occupational Health and Safety Administration. (U.S. Army; Josh Barchers.)

The Restoration Advisory Board (RAB) was established in 1994. The RAB consists of 15 members and serves as a forum to exchange information from the installation to the surrounding communities about the arsenal's cleanup program. The group has remained involved throughout the cleanup program and played a vital role in reviewing and commenting on cleanup plans and designs. (U.S. Army.)

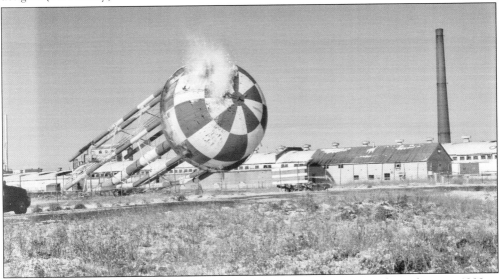

One of the Rocky Mountain Arsenal's most visible landmarks came crashing down in 1999 as part of the site's comprehensive structures demolition project. More than 10,000 tons of steel was recycled, including this water tower, during the cleanup program. (U.S. Army; Josh Barchers.)

The two on-site landfills at the Rocky Mountain Arsenal safely contain waste from the cleanup projects and are designed to last 1,000 years. The landfill's liner system is comprised of a protective soil base, two compacted clay layers, a leak detection and collection system, and a flexible synthetic membrane liner. This area will be maintained and owned by the U.S. Army. (U.S. Army; Josh Barchers.)

Pictured is a popular lake that many people enjoy on their hikes through the refuge. (U.S. Army; Rich Keen, DPRA, Inc.)

At 12,000 acres, the Rocky Mountain Arsenal National Wildlife Refuge is one of the largest urban refuges in the country. In 2004, the refuge was officially established after cleanup actions were completed and approved by the Environmental Protection Agency (EPA). By 2010, after cleanup is complete, the refuge will reach its final size of more than 15,000 acres. (U.S. Army; Rich Keen, DPRA, Inc.)

The Rocky Mountain Arsenal National Wildlife Refuge has more than 8 miles of hiking trails meandering through native short-grass prairie, woodlands, and lakeshores. (U.S. Army; Rich Keen, DPRA, Inc.)

Two of the arsenal's lakes provide excellent catch-and-release fishing. (U.S. Army; Rich Keen, DPRA, Inc.)

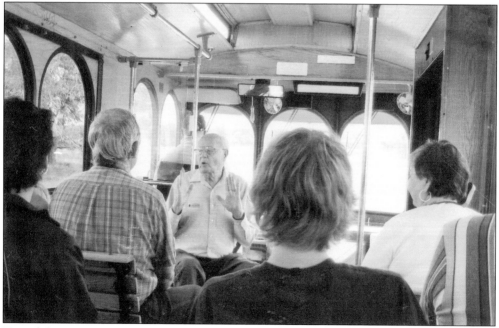

Two of the most popular ways to view the scenic Rocky Mountain Arsenal National Wildlife Refuge and its wildlife are on hayrides and bus tours. Pictured is tour guide Ernie Maurer. His family lived on the land before it became the site of the Rocky Mountain Arsenal in 1942. (Photograph by Debra Bullock.)

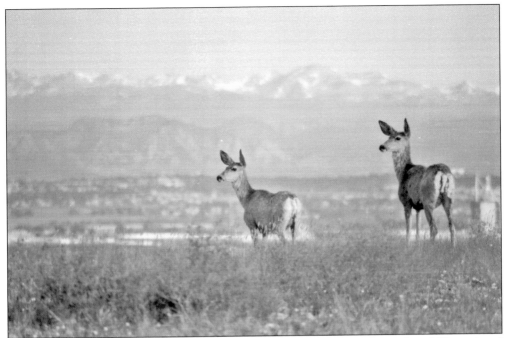

The Rocky Mountain Arsenal National Wildlife Refuge is home to more than 300 species of wildlife, including 600 mule and white-tailed deer. (U.S. Army.)

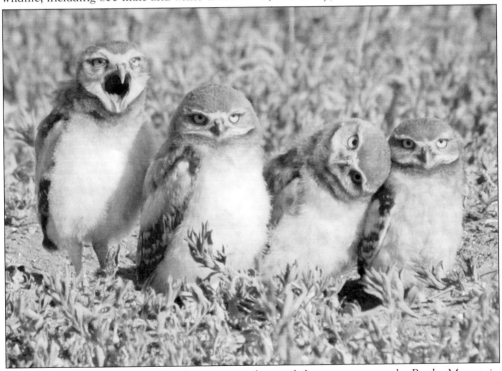

Weighing only five to six ounces, burrowing owls spend their summers at the Rocky Mountain Arsenal National Wildlife Refuge living in abandoned prairie dog towns. (U.S. Army; Rich Keen, DPRA, Inc.)

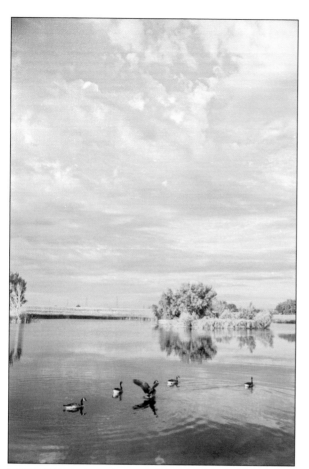

The three lakes at the Rocky Mountain Arsenal National Wildlife Refuge are a collective sanctuary for migrating and year-round waterfowl. (U.S. Army; Josh Barchers.)

As part of a nationwide conservation effort, 16 genetically pure American bison from the National Bison Range in Montana were reintroduced to the Rocky Mountain Arsenal National Wildlife Refuge on March 17, 2007. The return of the bison to the Rocky Mountain Arsenal National Wildlife Refuge signals remarkable progress both in the transformation of this site and in the conservation of American bison. The thriving herd continues to grow and totaled 41 bison by the fall of 2009. (U.S. Army; Rich Keen, DPRA, Inc.)

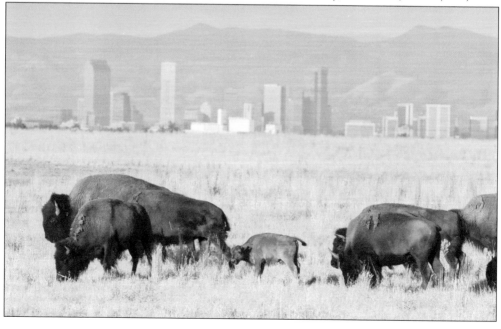

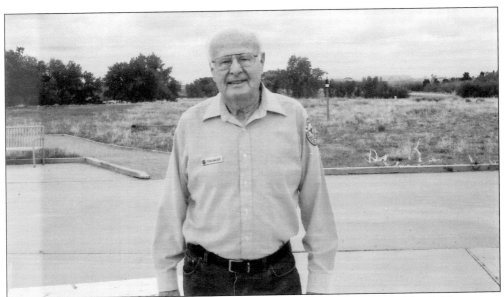

Ernie Maurer was born in 1922 into a family that farmed the future arsenal land. His parents came from Switzerland, his mom in 1903 and his father in 1910, and they were married in 1918. They had a small dairy—farmed 80 acres and rented 80 acres—where they raised corn, wheat, barley, and alfalfa. After moving off of the arsenal acreage in 1942, his family purchased land north of Sixty-second Avenue and Locust Street. The house moved from the arsenal and still stands with a new development built around it. Maurer's career was in education working in the Cherry Creek School District and northeastern Colorado schools. He is retired and currently lives in Denver. (Photograph by Debra Bullock.)

Pictured is the Egli family on July 4, 1942, just before they moved off of the arsenal land. This was the last family picnic at the family farm. (Lucille Egli McIntyre.)

Pictured is Lucille Egli McIntyre, the youngest of eight children, born in 1931. Her family was 1 of the 200 families that lived on the arsenal land. Her family farmed corn, alfalfa, and wheat. They milked 18 head of cattle and sold the milk. Her dad butchered his own meat, and they had a vegetable garden. Her mother canned vegetables, fruits, and meats for the winter. In 1943, her Dad purchased a 60-acre farm at Fifty-sixth Avenue and Holly Street on the southwest corner between Holly and Dahlia Streets. (Photograph by Debra Bullock.)

Royal Palmer moved to Derby in May 1947. He worked at the arsenal from 1953 until 1972; he was a machinist metal analyst. His favorite memories were of Derby and the hometown environment. Mr. Palmer is retired and still lives in Commerce City. (Hester Bonnell and Esther Hall.)

Four

SOUTH ADAMS COUNTY FIRE PROTECTION DISTRICT

No fire protection existed in the area that became Commerce City until after December 7, 1941, when the Japanese attacked Pearl Harbor. The local Civil Defense group crystallized firefighting efforts, organizing businesses and residents in Adams City, Derby, Irondale, Hazeltine, Henderson, Rose Hill, Welby, and all the rural areas surrounding them.

The South Adams County Volunteer Fire Department was formed on February 9, 1942, at a meeting held in the Adams City High School. Donations were made by Alfred Krogh (1935 Chevrolet truck), Gordon Hutchings (tank), and Marion Young (pump). These items were assembled into the first fire truck at the P & H Garage by Pete Greenemeier, Jack Greenemeier, and Earl Saurini. Originally all the equipment was donated by the volunteers themselves, and the first 10 years of the department were funded by donations and fund-raisers. On June 8, 1942, the department joined the Colorado State Firemen's Association.

In 1952, the South Adams County Fire Protection District, covering 27 square miles, was formed with a half-mill levy tax. The first board members were Floyd Templeton, president; Al Krogh, vice president; Earl Saurini, second vice president; David Tedesko, secretary; and Gordon Hutchings, treasurer.

In 1971, the Fire Prevention Bureau was established with the hiring of Don Kennerson as fire marshal. The South Adams County Fire Protection District was one of the first districts in the region to recognize the value of a Fire Prevention Bureau.

Carl Horblit worked for Mountain Bell Telephone Company in Yuma, Colorado, when he was transferred in 1941 to Adams City to manage the Hazeltine Phone Exchange. He had been the fire chief in Yuma and was elected the first fire chief of the newly organized South Adams Fire Department, serving from 1942 to mid-1945. His experience in the phone business helped firefighting, as he solved the situation of notifying firemen of emergency calls by providing operators at the telephone exchange with phone numbers of all volunteers, which were identified on the switchboards. Firemen were quickly notified. Carl transferred to the Golden, Colorado, Fire Department in 1960, where he became the chief of his third department. Carl passed away on April 29, 1974. The first officers of Adams City Fire Department were Chief Carl Horblit, Assistant Chief Marion Young, Capt. Gordon Hutchings, Lt. George Tressel, secretary Harold Hubbell, and treasurer Everett Reed. (Bob Hutchings.)

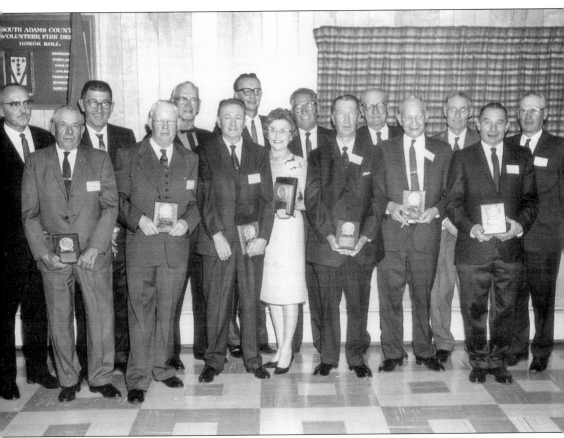

There were 20 charter members of the South Adams Fire Department. This photograph was taken in 1967 on the silver anniversary of the department at their annual dinner dance. Shown here are, from left to right, (first row) Howard Riedy, Orville Dornan, Bob Hubbell, Ruth Hubbell-Carlson (for her late husband, Harold Hubbell, who died in the line of duty as a fireman), Gordon Hutchings, Carl Horblit, and Jack Greenemeier; (second row) Herb Hast Sr., Earl Saurini, Everett Reed, Floyd Templeton, George Tressel, Alfred Krogh, Pete Greenemeier, and Kenneth Gahagen. Not pictured are Russell Gahagen, Lee Gotchall, Ludvig Toxvard, Floyd Wagner, and Marion Young. (Bob Hutchings.)

The first permanent fire station consisted of two truck bays constructed in 1943. The original truck was housed in an abandoned repair garage located on a triangular piece of property at East Sixty-ninth Avenue and Highway 85, east of Dahlia Street and west of the old Brighton Road. Meetings were held there, and the members sat on empty nail kegs donated by member Herb Hast Sr., who owned the local lumberyard. The first regular meeting was held on December 13, 1943. (Bob Hutchings.)

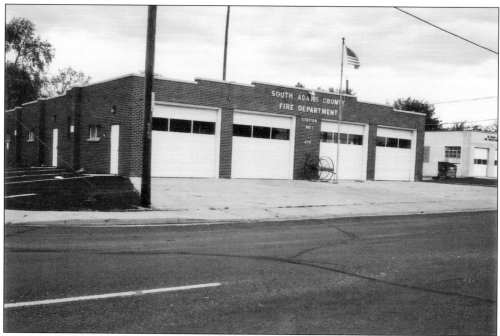

A new addition to this station was added in 1961, which consisted of enlarging two truck bays to four bays with a recreation/meeting room and larger kitchen. Large trophy cases were built to hold the many trophies won in various competitions. In 1974, the former Gulf service station adjacent to Station No. 1 was purchased and utilized as the maintenance facility. Pictured here is Station No. 1 today, located at 4711 East Sixty-ninth Avenue. (Bob Hutchings.)

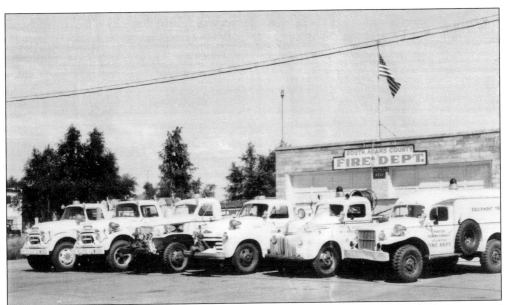

The first call answered by the department truck was on May 19, 1942, at East Fifty-sixth Avenue and the Sand Creek Bridge. It was also the first fire fatality, as a car with four 5-gallon cans of gasoline in the backseat pulled out into the path of a loaded gravel truck. The car driver burned to death. The department answered 69 fire calls in its first year with 30 volunteers. (Bob Hutchings.)

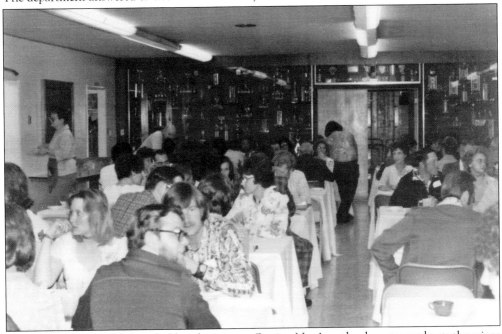

Ladies Appreciation Night is held each spring at Station No. 1, as the department hosts the wives to corsages, dinner, dancing, and a night out as a small reward for their husbands being gone so many hours all year long to emergency calls, training, meetings, fund-raising, and cleanup duties. Service pins are given to firefighters, earning them in five-year increments, and rookies are introduced. This annual tradition was started in 1944, when Carl Horblit was the chief. (Rick and Patti Teter.)

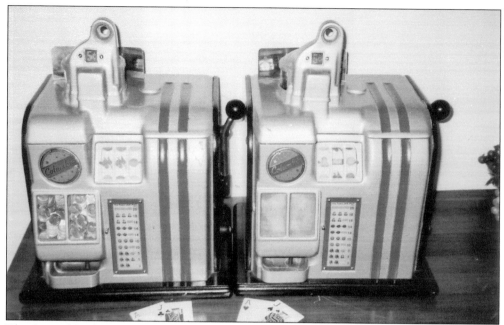

The Annual Jamboree was started as an annual fund-raising event. The first jamboree was held at the Adams City High School on May 13, 1944, with Floyd Templeton as chairman. All types of gambling games, including blackjack, Chuck-o-Luck, craps, bingo, and slots (pictured), were open to the public. This event was held annually from 1944 to 1955 until state and county officials placed restrictions on gambling, ending it all. (Bob Hutchings.)

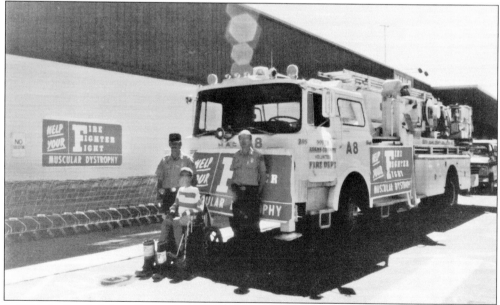

In 1954, the South Adams County Volunteer Fire Department voted to cooperate with the Colorado Fire Fighters Association and the International Association of Fire Fighters of America to assist the Muscular Dystrophy Association of America in raising funds. To this very day, the department is very active in the annual Labor Day Telethon raising money for this cause. Pictured are firemen Bob Kreutzer (left) and Kevin Phillips (right) and Troy Teter. (Rick and Patti Teter.)

April 5, 1955, was the date of the fire department's worst personal disaster. An explosion at the Oriental Refinery fatally burned Harold Hubbell (left). Five other firemen received burns. Past chief Harlow Leeper and his wife, Shirley, started a fund-raising effort on their 25th wedding anniversary in 1977 to provide money for equipment at University Hospital's Burn Unit. Harlow and others have raised more than $1 million since. Richard Watts (below) was fatally injured in an accident at East Sixty-fourth Avenue and Holly Street on April 29, 1982. He was responding to an apartment house fire in his personal vehicle when he collided with a Regional Transportation District bus in the intersection. These two memorial plaques have a prominent place in Station No. 1 as a collective tribute to the ultimate sacrifice these two men gave for the community. These two deaths are the only line-of-duty fatalities in Commerce City in nearly 70 years. (Both Bob Hutchings.)

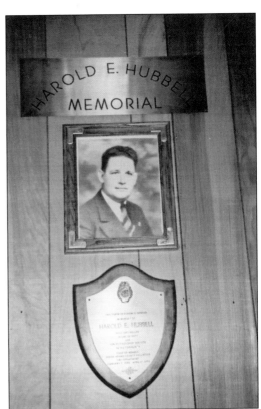

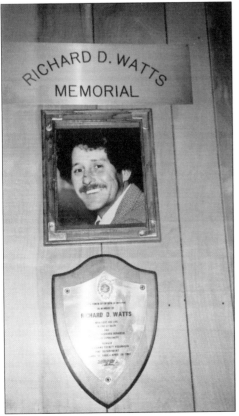

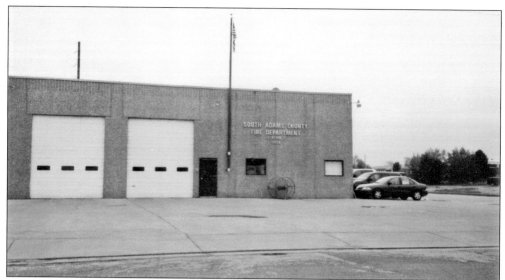

Original Station No. 2 was placed into service on February 13, 1956, at 5941 East Sixty-fourth Avenue. An addition was completed on August 25, 1969. Equipment was moved on July 12, 1977, to a new Station No. 2, located at 5650 Holly Street (pictured here). (Photograph by Debra Bullock.)

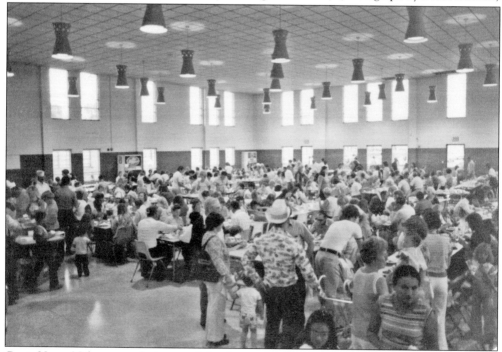

Capt. Harry Nelsen was chairman of the first annual spaghetti dinner as a department fund-raising effort held at expanded Station No. 1 on September 15, 1962. Tickets sold door to door by fireman produced a profit of around $1,400. The first cook was Jim Palombo. In a few years, it was moved to the high school cafeteria for added space (seen here). Currently hundreds of pounds of meatballs are rolled, and gallons of sauce are cooked by firemen and wives. This fund-raising event is currently held every September. In 2009, the event was held at the New Adams City High School. (Rick and Patti Teter.)

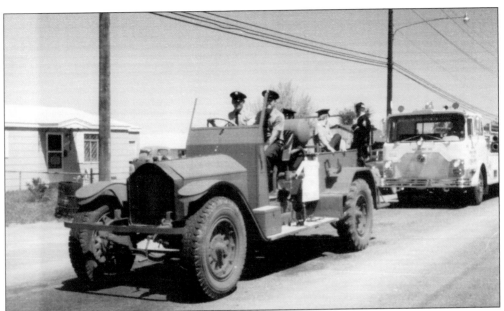

South Adams County Volunteer Fire Department purchased an old 1923 American LaFrance pumper for $1,200 on October 28, 1972. It was found by a South Adams fireman in Belle Fourche, South Dakota, parked behind a store building. The department has restored it for parades, conventions, and as a showpiece. It has won several trophies at shows and is currently housed at Station No. 4. (Bob Hutchings.)

A task force was formed in 1968 under the direction of Adams County sheriff Guy Van Cleave. The chairman of the taskforce was Jim Glassman. The purpose was to combine resources to deliver state-of-the-art services for 911 calls and dispatch. The South Adams County Fire District was a strong force in planning the communications center. Today the center is a nonprofit corporation governed by 13 agencies in Adams County. Don Meade and Rudy Ordquist were the first codirectors of the center; Bill Malone is the current director. (Bob Hutchings and Julie Blair.)

Construction for the Adams County Communications Center, located at 7321 Birch Street, began in 1974 and went live on the air on April 1, 1975, with the first call to Commerce City Police by dispatcher Julie Blair. On June 1, 1976, the center went to 911 dialing for emergency services, and enhanced 911 services came in 1991. The building has undergone two major remodels, including the most recent that was completed in May 2003. Pictured is the first building in 1975. That year there were 55 volunteers, two stations, and 11 pieces of equipment. (Bob Hutchings and Julie Blair.)

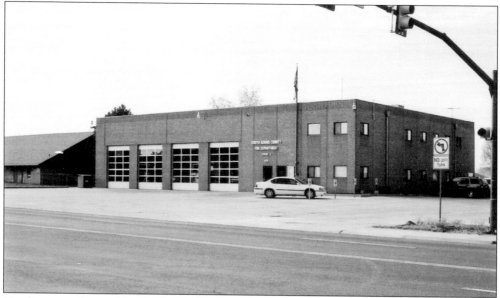

Headquarters Station No. 3 is located at 6550 East Seventy-second Avenue, which was opened in 1976. It was built with funds from a $700,000 bond issue approved by the voters in 1975. Four firefighting trucks and a new Station No. 2 were also included. The fire district acted as architect and general contractor, which secured a savings of $84,000 that was later used to build Station No. 4, located at 8600 Rosemary Street. Stations No. 2 and No. 4 are identical. (Photograph by Debra Bullock.)

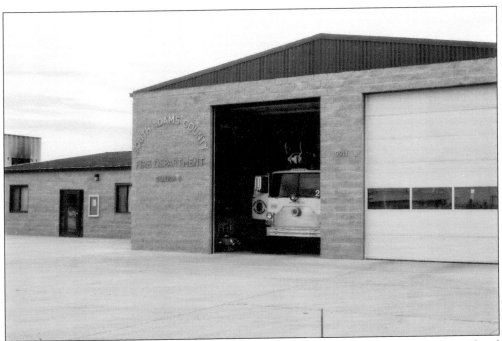

Station No. 5 (pictured) is located at 9911 East 104th Avenue. This firehouse was completed in 2000. It also has classrooms and the department's training facilities that were constructed in 2007. All types of fires can be simulated in the burn building and fuel tanker. A driving course can be set up on the 3-acre site. (Photograph by Debra Bullock.)

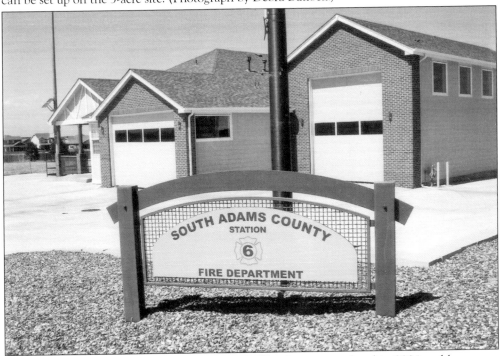

Firehouse No. 6 is located at 13691 East 104th Way. It was completed in 2004 and houses an engine and an ambulance. (Photograph by Debra Bullock.)

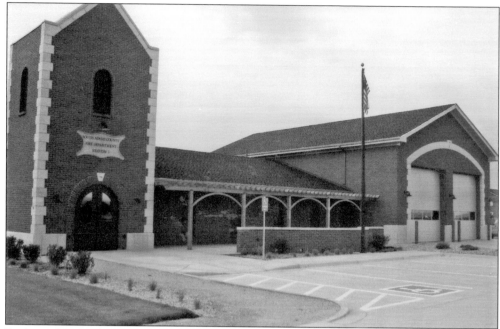

Firehouse No. 7 is located at 11200 East 112th Avenue and opened in May 2009. The cost of this beautiful building and land was $973,000. It was built to provide fire protection and ambulance paramedic service to the rapidly growing area in the northern part of the city. (Photograph by Debra Bullock.)

Firehouse No. 8 is the newest firehouse, located at 10326 Walden Street near Tower Road in Reunion, and was completed in September 2009. With new equipment ready to answer emergency calls, this four-bay station has a 2,400-square-foot community room in addition to full quarters for firefighters in the future. A paramedic ambulance also responds to all emergencies in the area. (Photograph by Debra Bullock.)

The South Adams County Fire Protection District is governed by five locally elected officials responsible for protecting 76 square miles of residential, commercial, industrial, and open lands. Pictured from left to right are (first row) vice president Rocky Teter and president Ken Kroger; (second row) director Darren Friess; secretary Randy Buckalew; and treasurer Bob Harpin. The current mill levy is 4.3 mills and is the lowest for an area the size of Commerce City. (Photograph by Jamey Buckalew.)

Pictured are the current officers for South Adams County Fire Department. From left to right they are R. J. Fernandez, lieutenant; Rick Hoffman, treasurer; Mike Fornili, secretary; Chad Ray, lieutenant; Bob Loop, lieutenant; Rick Bostedt, lieutenant; Ward Barnett, assistant chief; Ellis Howard, chief; Joe Kwiatkowski, assistant chief; Bobby Noel, lieutenant; Ricky Teter, training officer; Manny Sebedra, captain; Victor Loya, captain; and Derek Ross, captain. Officers not pictured are Brad Himmelman, lieutenant, and Walter Raven, lieutenant. (Photograph by Jessica Howard.)

Ellis Howard was elected chief in 2009 and leads the South Adams County Volunteer Fire Department with its eight stations and 17 pieces of firefighting equipment. There are currently 69 active volunteers with the department answering an average of 140 calls per month. Howard has been a member of the department for 14 years and had been a junior officer for six years. (Photograph by Jessica Howard.)

Pictured is the Fire Prevention Bureau. From left to right they are Dean Vitale, fire inspector; Kevin Vincell, deputy fire marshal; Ronald LaPenna, fire marshal; Kevin Phillips, deputy fire marshal; and Derek Ross, fire inspector. The bureau investigates all fires for origin, cause, and damage. They inspect commercial buildings and industrial facilities for fire code violations and general fire safety conditions. They review new building plans for fire code compliance, including sprinkler systems and fire alarm systems. (Fire Prevention Bureau.)

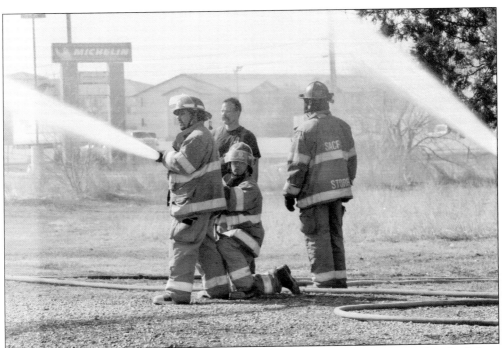

Pictured in a training session are, from left to right, firefighter Shane Gonzalez, firefighter Steve Tate (kneeling), training officer Ricky Teter (no helmet), and firefighter Chuck Storrs. (Ellis Howard.)

This photograph of the latest additions to the department's fleet was taken at the Pierce Manufacturing location in Appleton, Wisconsin, just prior to their trip to Commerce City in August 2009. The 75-foot ladder trucks cost $553,500 each, and the engines cost $371,800 each. An additional $80,000 in equipment and hoses for each was added here. The district was required to update an aging fleet, and because of a narrow bond issue defeat they are lease purchased. (Ellis Howard.)

Rick Teter became a rookie firefighter on May 29, 1973. Rocky and Randy Teter followed on May 13, 1974. Roy also followed with the Keenesburg Volunteer Fire Department in Weld County for 21 years and retired in 2005. Capt. Ricky Teter, who is Rick's son and a Denver firefighter, is a training officer for South Adams and joined the department on March 9, 1998. Chad Ray, who is a son-in-law of Rick Teter, joined the department in January 2000 and is currently a lieutenant. Rocky is still the longest active and tenured firefighter with the department. The total number of calls these three brothers and family have answered in Commerce City is over 40,000. Rick and Randy are now retired. The Teter brothers, pictured from left to right, are Roy, Rocky, Randy, and Rick. (Rick and Patti Teter.)

Bob and Dorothy Hutchings have lived in the area for nearly 80 years. They graduated from Adams City High School in 1948. After Bob spent nearly three years in the U.S. Air Force, the next 30 years went by raising two children and several million trout at Hutchings Trout Farms. In addition to this full-time job, Bob became a volunteer fireman like his father, Gordon Hutchings, and held various fire organization offices locally and statewide. (Bob Hutchings.)

Five

SOUTH ADAMS COUNTY WATER AND SANITATION DISTRICT

The South Adams County Water and Sanitation District was formed by citizens and business associations in 1951. The citizens' group, headed by chairman E. C. Everett Reed, Mr. Iverson, and Alvin Kinsall, organized public meetings, studied engineering reports, and recommended a quasi-municipality to be known as the South Adams County Water and Sanitation District.

The district court in Brighton held hearings on August 9, 1951, and called for an election on September 11, 1951, resulting in the legally recognized district on September 20, 1951. On the first board of directors were Everett Reed, A. E. Kinsall, Earl Goble Jr., C. M. Edwards, and E. C. Francon.

The first vote on sanitation was held in September 1952 and was defeated. Consequently, the board called for a bond election on December 30, 1952, to establish water and sanitation facilities. The water issue was successful, and the sanitation issue was defeated once again.

The district's water system developed in three phases. The first phase from the 1950s to the 1980s mainly consisted of developing the groundwater systems and infrastructure throughout the city. The second phase of water system development occurred from 1984 to 1999 and was concerned with groundwater contamination that originated from operations at the Rocky Mountain Arsenal and other nearby Superfund contamination sites. This period resulted in the construction of the 12-million-gallons-per-day Klein Water Treatment Facility and the addition of 4,000 acre feet of treated water supplies from Denver Water.

The third phase of water system planning occurred from 1999 into the 21st century in response to new development. The district has acquired and began implementing water resources and infrastructure improvements sufficient to supply an additional 33,000 single-family residences.

The original project costs were approximately $1,235,000 in 1957, when the district's assets were approximately $4 million dollars. In 2009, the district's assets were approximately $316 million.

Pictured is the board of directors in 1957–1958. From left to right are Ernest Martin, masonry contractor/owner; Russel Harner, Firestone Store; Julian Ron Pershing, Public Service Company; Pete Merilatt, donut shop owner; and Carlyle "Curly" Edwards, employee from a refinery. Staggered elections are held every two years. Each director is elected to a four-year term with term limits of eight years. (South Adams Water and Sanitation District.)

This is the administration building, still located at 6595 East Seventieth Avenue. The building was constructed in 1953. It was remodeled in May 1976 and again in 1988, with the addition of the boardroom. This location also included the first pump station. (Photograph by Debra Bullock.)

The original water system consisted of three deep wells, approximately 750 feet deep, to what is known as the "Arapahoe" formation and one deep well approximately 1,500 feet deep to the "Laramie-Fox Hill" formation. These wells were drilled by Hier and Price Contractors during the early part of 1953. Pictured is the pump station and reservoir located at Sixty-fourth Avenue and Quebec Street, which was built in 1953. (South Adams County Water and Sanitation District.)

The distribution system was installed by Parrish-Linneman Construction Company and consisted of approximately 53 miles of mains. The first fire hydrants were installed in 1953. Four 300,000-gallon reservoirs and booster pumping stations were constructed by Nielsen-Dougan Construction Company in 1953. Two of the reservoirs were located at Seventieth Avenue, one at Sixty-fourth Avenue and Quebec Parkway, and one at Eightieth Avenue and Jasmine Street. Pictured above is the pump station and reservoir located at Eightieth and Jasmine. (South Adams County Water and Sanitation District.)

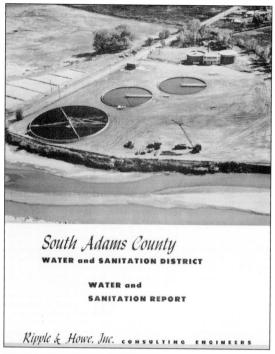

The installation of the water system accelerated the growth of the area and at the same time increased the need for sanitation. It was not until March 13, 1956, that an election was approved for the installation of a sanitary sewer system and sewage treatment facilities. The board of directors who called for the successful sanitation election consisted of E. C. Francon, president; P. G. Merilatt, secretary; C. Edwards, treasurer; E. Martin, director; and E. Saurini, director. (South Adams County Water and Sanitation District.)

The Williams Monaco Wastewater Treatment Plant is named after Al Williams, who served as the mayor of Commerce City from 1975 to 1978 and was the president of the water district from 1961 to 1978. The plant was built in 1958 and renamed after Al Williams in the late 1970s. The plant is located at Ninety-sixth Avenue and Monaco Street. (South Adams County Water and Sanitation District.)

The treatment plant has the capacity to process 8 million gallons of sewage per day. Currently the plant treats approximately 3.5 million gallons per day. The treatment plant consists of screening primary sedimentation, followed by biological treatment, final clarification, disinfection, and discharge to the South Platte River. The methods used to treat wastewater have evolved greatly over the district's lifetime. Pictured is the original rock-media trickling filter system constructed in the late 1950s that showered water over waste-eating bacteria that resided on ordinary rocks. (South Adams Water and Sanitation District.)

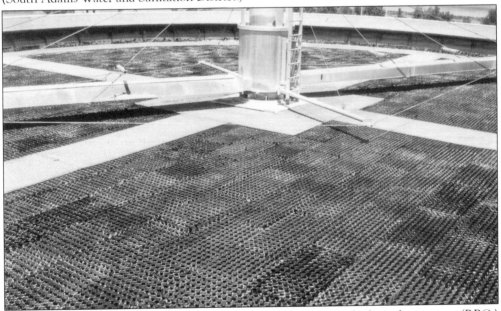

Treatment was subsequently enhanced with the addition of rotating biological contactors (RBCs) in the early 1980s. A Biotower, which housed bacteria on modules of corrugated plastic, was constructed in the early 1990s to increase pollutant removal capabilities. Pictured is the process of the original rock-media trickling filter system constructed in the late 1950s. (South Adams County Water and Sanitation District.)

This is the outside view of the Biotower. (South Adams County Water and Sanitation District.)

This is a state-of-the-art moving bed biological reactor (MBBR) that the sanitation plant currently uses. This process uses plastic pasta-shaped media to house both aerobic and anaerobic microbes that purify the wastewater. The treatment process progression has provided increased treatment efficiency in response to increasingly stringent limits on discharges to the South Platte River. (South Adams County Water and Sanitation District.)

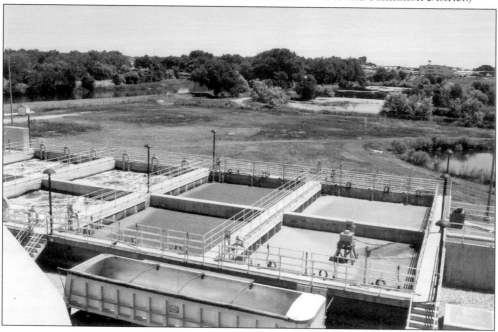

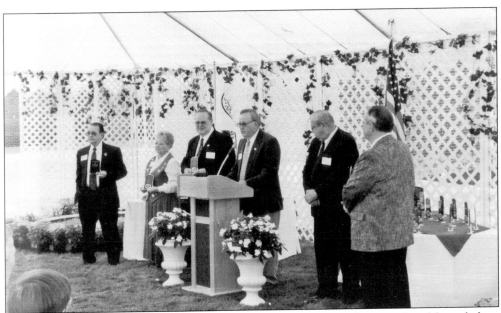

In 1984, the South Adams County Water and Sanitation District discovered trichloroethylene (TCE) in its shallow wells. One source of the contamination was the nearby Rocky Mountain Arsenal, where chemical weapons and pesticides had been produced in the past. District officials approached the army, and as a result the army, the Environmental Protection Agency, Shell Oil Company, and the State of Colorado provided funds in excess of $15 million dollars to construct the 12-million-gallons-per-day treatment plant. The Klein Water Treatment Plant, seen below, is located at 7400 Quebec Street on the 12-acre parcel of land donated by the army from the Rocky Mountain Arsenal and was named after Jean Klein, who was the president of the district from 1978 to 2004. The ground-breaking ceremony was held on September 9, 1988, and the opening ceremony was held in November 1989. Pictured above is the 10th-anniversary ceremony in 1999. (Both South Adams County Water and Sanitation District.)

The Klein Water Treatment Facility has two separate laboratories. One of the labs houses a Gas Chromatograph/Mass Spectrometer, a sophisticated piece of equipment that is designed to specifically detect organic compounds like those that were found in the district's groundwater supplies. Pictured is chemist Jonathan Gaudreau, who works in the lab and tests water on a daily basis. (South Adams County Water and Sanitation District.)

The district's water laboratories were recently named 2009 Water Laboratory of the Year for the Rocky Mountain Section of the American Water Works Association. Seen here is chemist Kevin Pustulka, who works in the water lab and tests water on a daily basis. (South Adams County Water and Sanitation District.)

The Klein Water Treatment Facility utilizes a granular activated carbon (GAC) treatment process. The GAC will absorb volatile organic compounds, such as TCE, and remove them from drinking water. (South Adams County Water and Sanitation District.)

Larry Ford was the general manager for the water district for over 40 years. He started with the district in 1957, and he retired in 2004. He was elected to the board of directors in 2006. Water board members and management made many trips to the Pentagon to negotiate settlements with the army for the contamination from operations at the Rocky Mountain Arsenal. Larry made 22 trips to Washington, D.C. Larry and his wife, Darlene, have lived in the Commerce City area since 1957. They have three children, Larry Jr., Heidi, and Sean; 11 grandchildren; and three great-grandchildren. (Photograph by Debra Bullock.)

A major component of the district's water supply comes from alluvial wells. These wells are directly connected to the South Platte River. The amount of water pumped from the wells requires full replacement to the river. The district accomplishes this by returning the bulk of the water back to the river at the wastewater plant, supplemented by timely releases of senior surface water rights. Water from the Burlington Ditch enters the Ford Alluvial Recharge Facility (named after Larry Ford), where it percolates into the ground and gradually works its way back to the river. (Both South Adams County Water and Sanitation District.)

Starting around 1986, the South Adams Water and Sanitation District has entered a float in the yearly Commerce City Memorial Day Parade. It has placed "best entry" for several years. The district is very active within the community, and it participates in many area events throughout the year. Bob Aragon, a district board member, is pictured at right on one of the floats from 2004. (Both photographs by Debra Bullock.)

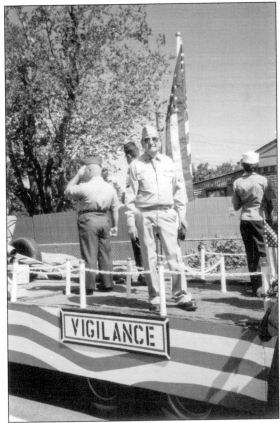

In 1996, the U.S. Army and Shell Oil Company agreed to fund the Henderson Pipeline Project. There were approximately 200 private wells in the Henderson area that were affected by groundwater contamination that migrated off of the Rocky Mountain Arsenal. The army and Shell agreed to pay for the water pipelines and tap fees necessary to connect the affected parties to the South Adams County Water supply system. Pictured above is the ground-breaking ceremony for the Henderson Pipeline, and pictured below is the Henderson Pipeline construction. (Both South Adams County Water and Sanitation District.)

This is the newest pump station, which opened in July 2009, located at 10270 Landmark Drive in the Reunion/Landmark subdivision. This pump station houses a 4 million-gallon reservoir with available land to expand up to 16 million gallons of reservoir capacity in the future. The land for this site was purchased by South Adams County Water and Sanitation District from Shea Homes. (South Adams County Water and Sanitation District.)

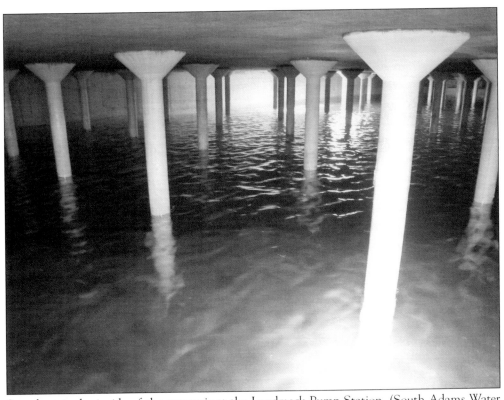

Seen here is the inside of the reservoir at the Landmark Pump Station. (South Adams Water and Sanitation District.)

The Denver Water Department and the district have an agreement to jointly construct water storage. Shown is a picture of Miller Lake and Cat Lake. These lakes were established in 2009. They are located across the South Platte River from each other at roughly Sixty-ninth Avenue and the South Platte River. Miller Lake, on the east side of the river, is named after Esther Miller for the family land. Cat Lake, located on the west side of the river, is named after Cat Construction, which was the company that owned the property. (Denver Water Department.)

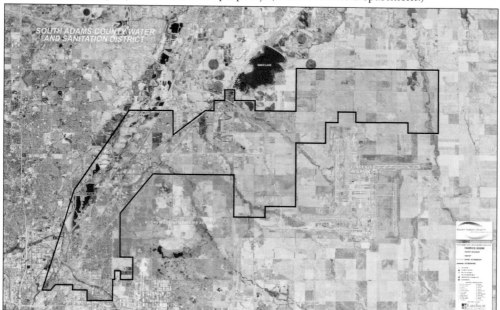

In 1951, the district consisted of approximately 14 square miles, bounded on the south by the City and County of Denver, on the west by the South Platte River, on the east by the Rocky Mountain Arsenal, and on the north at Ninety-sixth Avenue. Today the South Adams County Water and Sanitation District service area covers approximately 65 square miles and currently serves approximately 40,000 residents. (South Adams County Water and Sanitation District.)

1 acre foot volume

66 feet

660 feet

Since its inception, the district has implemented 29,000 acre feet of water supply, installing approximately 450 miles of water distribution lines and 250 miles of sewer mains; nine water pumping stations with 43 million gallons per day of pumping capacity; nine water system reservoirs with 16 million gallons of storage capacity, codeveloping with Denver Water; 21,000 acre feet of surface water storage; 12 wastewater lift stations; and a wastewater plant with 8 million gallons per day of treatment capacity. (Debra Bullock.)

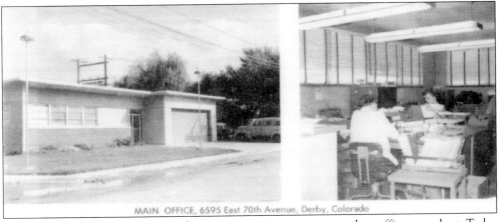

MAIN OFFICE, 6595 East 70th Avenue, Derby, Colorado

The district started with three employees: an operator, manager, and an office attendant. Today there are 89 employees and four departments. Pictured here is the first office at 6595 East Seventieth Avenue. (South Adams County Water and Sanitation District.)

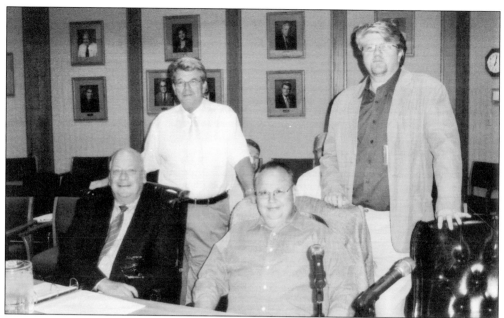

Here are the department managers. Pictured from left to right are (standing) Jim Pankonin, distribution and collection system manager, and Curtis Bauers, water system manager; (sitting) Terry Funderburk, finance manager, and J. M. Grebenc, wastewater system manager. (Photograph by Debra Bullock.)

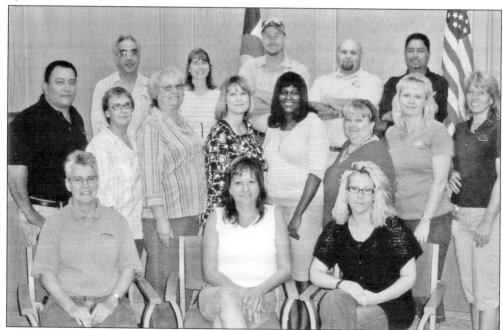

These are some of the current employees of the South Adams County Water and Sanitation District. They are, from left to right, (first row) Charlene Seedle, Sandy Stewart, and Jen Pillington; (second row) Russ Herrea, Vickie Canter, Ruthie Pfarr, Pam Latta, Lazette Gaines, Vicky Palmer, Debbie Evans, and Terri Golden; (third row) Tony Francisco, Cheryl Layton, David Goff, Curt Evans, and Danny Arguello. (Photograph by Debra Bullock.)

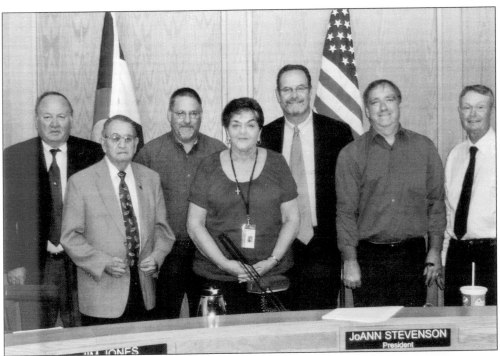

Pictured is the current (2009) board of directors with the district manager and general counsel for the South Adams County Water and Sanitation District. They are, from left to right, Larry Ford, director; Robert J. Aragon, secretary; Jim Jones, general manager; JoAnn Saurini-Stevenson, chair; Timothy J. Beaton, legal counsel; John R. Ennis, director; and Glenn Murray, treasurer. (Photograph by Debra Bullock.)

Al and Jean Klein moved to Commerce City in June 1954. Their first house was at 5400 Locust Street. Jean has been a driving force in many community organizations. She was a city charter delegate in 1970. She served on the South Adams County Water and Sanitation District from 1974 and was president from 1978 to 2004. Al and Jean also owned Jean's Realty for 40 years, retiring in 1999. Al and Jean have three children, six grandchildren, and four great-grandchildren. They currently live in Commerce City at 5501 East Sixty-fourth Avenue in the same home they purchased in 1963. One of Jean's favorite memories is being Mrs. Claus for the annual children's holiday event at the Catholic church, which she participated in from the late 1970s until 2004. (Jean Klein.)

113

The Commerce City Business and Professional Association established an annual Christmas with Santa in the Derby area, which was held at banks and churches. Pictured is Jean Klein as Mrs. Santa, Joe Reilly as Santa, Reba Drotar, and pilot Gary Drotar at Metropolitan State Bank on December 13, 1984. Over 2,000 children attended. (Reba Drotar.)

Dick and JoAnn Stevenson have been lifelong citizens of Commerce City. JoAnn was born in Commerce City, and Dick has lived in Commerce City for 50 years. Their five daughters were born in Commerce City. JoAnn's parents, Earl and Teresa Saurini, were children of Italian immigrants. Earl's given name was Rosario, but his older sister told the teacher to call him Earl. The sister had a crush on a boy named Earl, and that is how she made the decision; Her father kept the name Earl. The Saurini family lived in Irondale and Adams City. Dick was a Rotary Club member for 50 years, and JoAnn is president of the South Adams County Water and Sanitation District. They have five daughters, 13 grandchildren, and two great-grandchildren. (Photograph by Debra Bullock.)

Six

COMMERCE CITY
POLICE DEPARTMENT

The Commerce City town marshal from March 1950 to August 1950 was Marshal Kellogg. He was replaced by Edward A. Marzano, who was named as the first chief of police. The police department in the 1950s was located at 6019 Forest Drive in an old army barracks. Officers were paid about $225 per month. The cost of a police uniform in 1957 was approximately $25.

In 1961, the police department consisted of a chief, sergeant, six patrolmen, and a dogcatcher. When the town added the position of dogcatcher in the early 1960s, the board also passed the first dog leash laws and rabies ordinances. A requirement of the department was that every two years each member had to be reappointed to his or her position. K9 units were introduced into the department in 1966 and later reintroduced under Chief Hebbard.

In 1970, the police department began operating its own ambulance, donated by the Mile High Kennel Club. In 1970, the department included four divisions: Administration, Investigations, Staff Services, and Patrol, with seven police cars. In October 1978, an explosion occurred at the Continental Refinery. The department worked hand in hand with the South Adams County Fire Department to bring the fire under control. The blast broke windows as far away as Derby.

As the department entered the 1980s, it found new challenges with growth. The department saw its call for service with the population rising from 10,000 in 1970 to 21,038 in 1980. Lt. Wes Wilson started the first Citizens' Academy in Colorado. Today the Commerce City Police Department still oversees a Citizens' Police Academy. In the 1990s, the force grew to 78 officers.

The events of both the Columbine High School tragedy and the terrorist act on the World Trade Center towers in New York City on September 11, 2001, led the city to create the department of emergency preparedness. In April 2007, the police department moved into the new civic center, located at 7887 East Sixtieth Avenue.

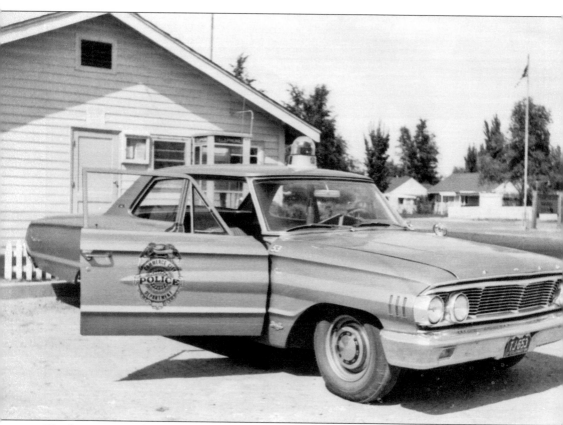

The first town marshal in 1952 was Marshal Kellogg. He initially reported to the director of public works, William Weimar. The town was patrolled only during the day. The police committee consisted of two council members and William Weimar. Marshal Kellogg was replaced by Edward A. Marzano, who was named the first chief of police in September 1952. On February 24, 1954, the town authorized the purchase of its first police car, which cost $2,012 and $7.40 for license plates. Pictured is a Commerce City police car, a 1964 Ford, equipped with a siren, bubble light, and a county radio. (Lt. Chuck Saunier and Comdr. Larry Woog, Commerce City Police Department.)

In the mid to late 1950s, the officers were tasked with patrolling the main streets, animal control, traffic flow, and parking control around the Mile High Kennel Club. During a typical shift, an officer might stop by Martha's Grocery Store (6400 Brighton Boulevard) to make sure there were no local kids trying to purchase beer. One of the oldest citations found in the city archives is dated January 1956 and was issued for the sale of alcohol to a minor. Pictured at right is Gil Hoffman, who was hired in 1961 and retired in 1981. He passed away in April 2007. (Vivian Hoffman.)

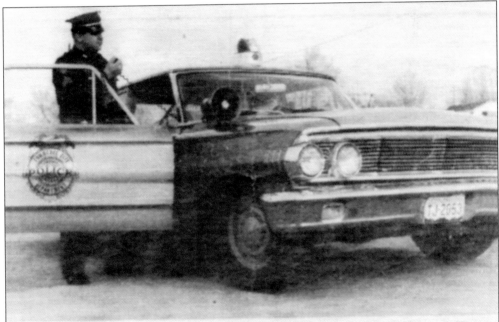

Sgt. Warren Kerls is using the public address system the association installed on one of the patrol cars. The PA also serves as an outside speaker should the officer be away from his car, a civil defense alert system and an electronic siren which can be operated either manually or automatically.

In 1960, Richard Kuykendall was named the new chief. During the 1960s, police officers would rush accident victims to the nearest hospital. After a town board meeting in October 1961, it was determined that an officer would "use his own discretion as to whether or not to call an ambulance or use a police car for emergency runs to any hospital." During this board meeting, the owner of Ford Adams County Ambulance expressed his concerns about this practice, causing him to lose business. Pictured is Sgt. Warren Kerls using the public address system installed in the patrol cars. (Lt. Chuck Saunier and Comdr. Larry Woog, Commerce City Police Department.)

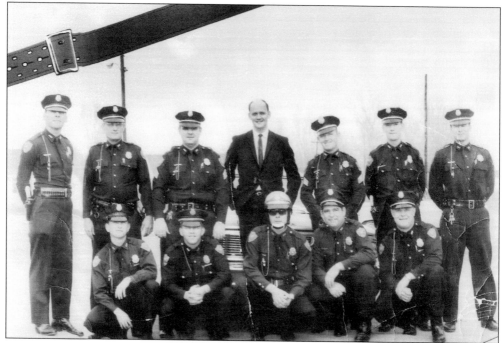

In 1961, Reed Miller was named chief of police and was the last to be promoted within the ranks of the police department. Miller's challenge was an increasing population and all that was associated with growth at the time. The town had grown to 16,500 residents. The department consisted of one chief, one sergeant, six patrolmen, and one dogcatcher. In 1966, Ben Roach was named chief of police. Pictured is Reed Miller (standing in the center with the suit and tie) with the police department in 1963. (Vivian Hoffman.)

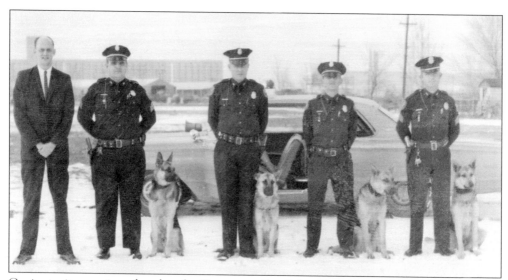

Canine units were introduced to the Commerce City Police Department in 1966. The program was dropped due to funding issues. (Lt. Chuck Saunier and Comdr. Larry Woog, Commerce City Police Department.)

Chief Hebbard brought back K9 units. Ray Hernandez was one of the officers to have a canine partner (Cesar). After Hernandez died on November 8, 2002, officer Mark Douglas became Cesar's handler until August 20, 2007, when Cesar was retired. Two other dogs, Charlie and Condor, were in the canine program. Charlie died suddenly in May 2006, and Condor worked for seven years from August 2000 to April 2007. The current canine unit consists of officers Mark Douglas (Cobra) and Thomas Boskovich (Cario). Pictured are Ray Hernandez and Cesar. (Kelly Hernandez.)

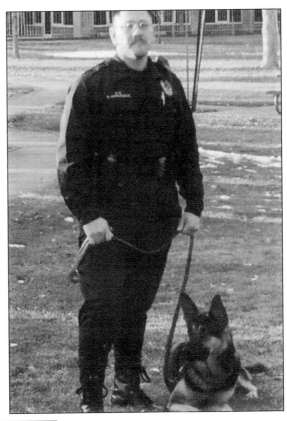

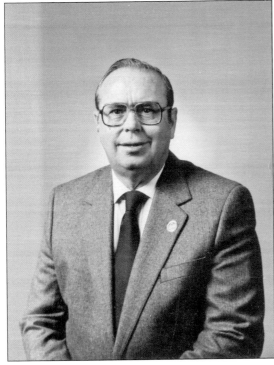

In 1970, the police department had grown to four divisions, and it was evolving from a small-town police force to a "city" police department that was dealing with an increase in crime. In 1972, Chief William Beary replaced Chief Ben Roach. In 1974, Neil Wikstrom was named police chief, hired from the Littleton Police Department. Wikstrom became the longest-tenured chief, serving until 1990. (Lt. Chuck Saunier and Comdr. Larry Woog, Commerce City Police Department.)

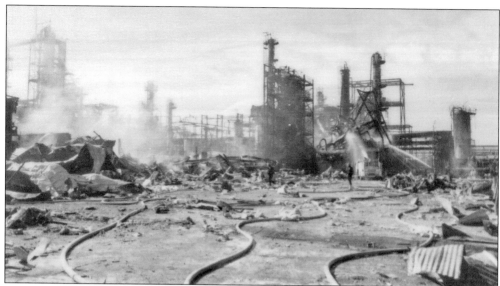

In October 1978, there was an explosion at the Continental Refinery (now Suncor). The police department and the South Adams Volunteer Fire Department worked hand in hand to bring the fire under control, including current division commander Larry Woog. The blast broke windows as far way as Derby and was felt throughout the metro area. This was the largest fire recorded in Commerce City history. (Lt. Chuck Saunier and Comdr. Larry Woog, Commerce City Police Department.)

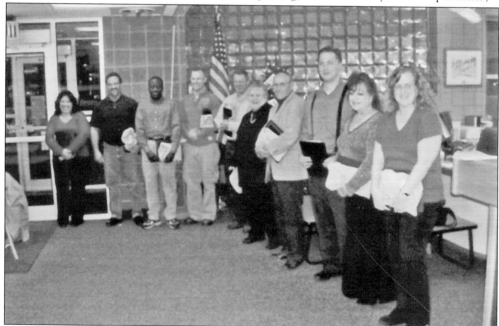

In 1987, Lt. Wes Wilson started the first Citizen's Police Academy in Colorado. During the academy, the participants cover a variety of topics, including professional standards, criminal law, victim services, street crime, crime analysis, and firearms. Today the Commerce City Police Department still oversees a Citizen's Police Academy. Pictured is the graduation for the Citizen's Police Academy on November 30, 2006. (Lt. Chuck Saunier and Comdr. Larry Woog, Commerce City Police Department.)

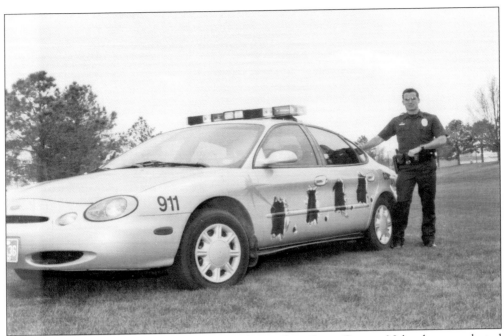

In 1990, after Chief Wikstrom retired, Jim Sanderson, from Sarpy County, Nebraska, was selected as police chief. He was instrumental in bringing the DARE program and Neighborhood Watch to the city. He also developed a partnership with School District 14 and the Red Ribbon Campaign (students choosing to stay drug free) and developed a gang intervention unit. Pictured is one of the DARE cars and officer Dave Cubbage, who is now a patrol lieutenant. (Lt. Chuck Saunier and Comdr. Woog, Commerce City Police Department.)

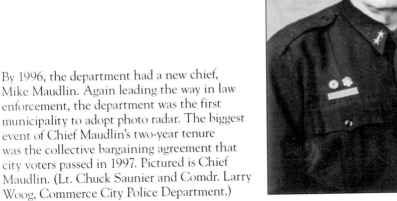

By 1996, the department had a new chief, Mike Maudlin. Again leading the way in law enforcement, the department was the first municipality to adopt photo radar. The biggest event of Chief Maudlin's two-year tenure was the collective bargaining agreement that city voters passed in 1997. Pictured is Chief Maudlin. (Lt. Chuck Saunier and Comdr. Larry Woog, Commerce City Police Department.)

In June 1998, Brian Hebbard was hired as chief to help prepare the Commerce City Police Department for unprecedented growth. On April 20, 1999, the Commerce City Special Weapons And Tactics (SWAT) team assisted in the Columbine High School shootings, and in 2001 the city moved to create the department of emergency preparedness after the World Trade Center bombings on September 11, 2001. The SWAT team was renamed the Special Services Unit (SSU). In 2006, in reaction to citizen concern to the growing gang and graffiti problem in the city, the police department created the Street Crime Attack Team (dubbed SCAT) that is currently called Special Investigations Unit (SIU). It works with other divisions to identify trends and develop strategies for crime prevention. (Lt. Chuck Saunier and Comdr. Larry Woog, Commerce City Police Department.)

In December 2006, a record snowfall from two major snowstorms a week apart brought more than 40 inches of snow. Roads across the metro area were closed by four- and five-foot drifts. Every city-owned four-wheel-drive vehicle became a makeshift patrol car. Police department and public works employees worked around the clock. In early 2007, Chief Hebbard (pictured with his wife, Sharon) retired after serving nine years as chief of police and 34 years in law enforcement. During his tenure, he worked to enhance the police department reputation. Charles Baker was appointed acting police chief from early 2007 until 2008. (Photograph by Debra Bullock.)

On April 7, 2007, the Dick's Sporting Goods Soccer Park opened. Five days later, the city's government, including the police department, moved into the new civic center complex next door to the soccer stadium. (Photograph by Debra Bullock.)

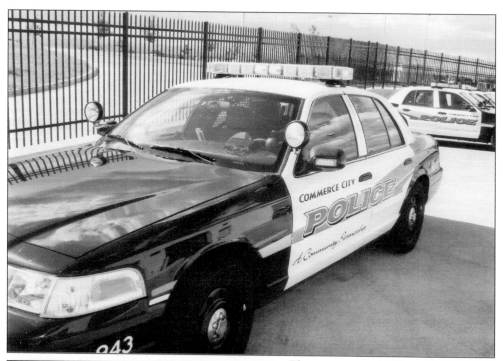

There are currently 39 patrol cars in Commerce City. A new police car equipped with all the needed equipment currently costs $41,000, not including GPS systems, computers, etc. The men and women of the Commerce City Police Department do not perform their jobs for the fame or for the money. They do this as a true calling to serve their community. (Photograph by Debra Bullock.)

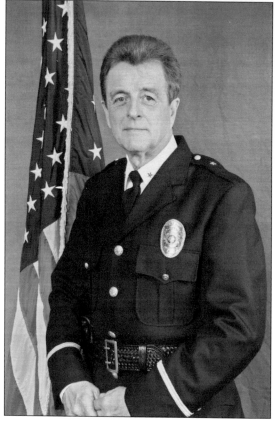

Pictured is Comdr. Larry Woog. Commander Woog started with the police department on May 1, 1972. He is currently the longest-term employee within the city and the police department. He started as a patrolman and worked his way to commander. (Comdr. Larry Woog.)

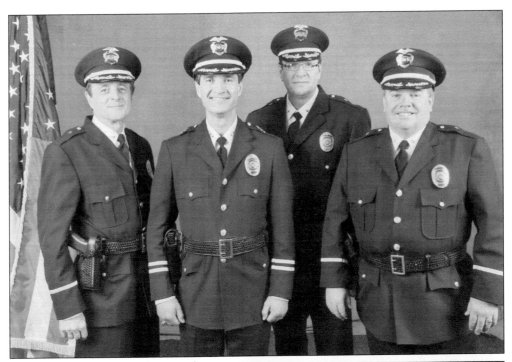

Currently there are three commanders and a chief serving the police department. From left to right are Larry Woog, commander for support operations, the detectives, and special units; Chief Phillip Baca; Comdr. Chuck Baker, who controls the patrol division, traffic, dogs, animal control, and community service officers; and Comdr. Ross Sibley, the head of internal affairs, recruiting, hiring, training and accreditation, volunteers, and emergency management. (Lt. Chuck Saunier and Comdr. Larry Woog, Commerce City Police Department.)

The current police chief is Phillip Baca from the Jefferson County Sheriff's Department. He was hired in January 2008. Today the Commerce City Police Department employs 93 commissioned officers and 28 non-sworn employees, protecting over 40,000 residents. The current cost of a uniform is around $1,800, and the starting salary for a police officer is $51,492. (Lt. Chuck Saunier and Comdr. Larry Woog, Commerce City Police Department.)

Pictured are Warren and Carolyn Kerls. They moved to Commerce City in 1962. Warren was one of the city charter delegates in 1970. He worked for the police department from 1962 to 1992, when he retired. He started as a policeman and finished his career as the assistant police chief. He was one of the founding members of the liquor board in 1995 and has served on the South Adams County Water and Sanitation District Board and the police pension board. Warren and Carolyn, Commerce City residents, have two children, Melanie and Bud, and five grandchildren. (Photograph by Debra Bullock.)

Past Police Chiefs

Edward Marzano, 1950–1955
Charles Dickerson, 1955–1960
Richard Kuykendall, 1960–1961
Reid Miller, 1961–1966
Ben Roach, 1966–1972
William Beary, 1972–1974
Neil Wikstrom, 1974–1990
Jim Sanderson, 1990–1996
Mike Maudlin, 1996–1998
R. Brian Hebbard, 1998–2007
Charles Baker-Acting, 2007–2008
Philip Baca, 2008–present

United Residents for Commerce City (URCC), founded in 2008 by Rene and Debra Bullock, was formed to enhance the community by creating significant and meaningful participation through events and preserving history. The committee collected documents and solicited resident participation. The charter members were Rene Bullock, Debra Bullock, Sean Ford, Samantha Ford, JoAnn Saurini-Stevenson, Dick Stevenson, Thelma Cole, Joy Bishop, Gene Leffel, Dustin McIntyre, Esther Hall, Hester Bonnell, Bob Hutchings, Dorothy Hutchings, Gary Comstock, Cindy Comstock, Reba Drotar, June Younger, Don Sater, Loretta Petty, Steve Douglas, and Kristi Douglas. (Reba Drotar.)

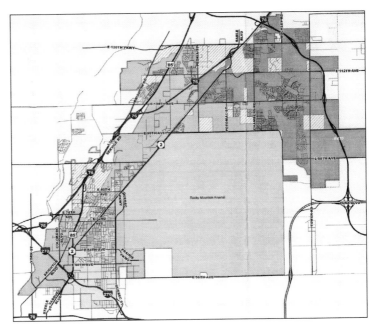

Pictured is the current land boundary map of Commerce City. (City of Commerce City.)

DISCOVER THOUSANDS OF LOCAL HISTORY BOOKS FEATURING MILLIONS OF VINTAGE IMAGES

Arcadia Publishing, the leading local history publisher in the United States, is committed to making history accessible and meaningful through publishing books that celebrate and preserve the heritage of America's people and places.

Find more books like this at
www.arcadiapublishing.com

Search for your hometown history, your old stomping grounds, and even your favorite sports team.